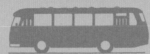
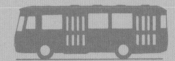
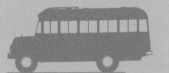
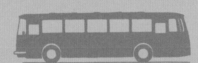

T0317849

СОВЕТСКИЕ АВТОБУСНЫЕ ОСТАНОВКИ
ТОМ II

SOVIET BUS STOPS VOLUME II

CHRISTOPHER HERWIG

FUEL

Ducks, Decorated Sheds and Felix Dzerzhinsky
The Politics of Small Architectural Forms

Owen Hatherley

Most of my experience of the former Soviet Union is urban, and when I've travelled between towns and cities, it has usually been by train. So despite knowing much of the western part of the former USSR reasonably well, I haven't seen a single one of these bus stops in situ. There are only two exceptions where the bus stops I've encountered have been compelling. One was the road from Boryspil airport in Kiev to the nearest Metro station, where colourful pavilions – one part 1960s LA and one part imagined Ukrainian folk art – form a striking contrast to the ubiquitous advertisements. The other was on a long drive between Kiev and the 'atomgorod' of Slavutych, near the Belarusian border. Chic, if extremely worn, bus stops were scattered by the smallest hamlets, each with an optimistic sign giving the name of the town or village. 'Progress' turns out to be a hamlet of around five houses; I did a double take at 'Coca-Cola Factory' before I saw in the near distance a long, low building with the distinctive red-and-white logo of imperialist beverage manufacture.

The state of the bus stops here seemed to mirror the state of the road itself, which was in a sense beautifully engineered – cutting a long, clear, straight path through the forests and fields of Chernihiv Oblast – but with a surface that changed as if at random from a bone-shaking ride over poorly laid, worn tarmac to sudden and unexpected smoothness, where some unusually enterprising local authority had bothered to repave it. The stops were in a near-uniform style of concrete or wood slotted together into laconic yet futuristic shapes, much more interesting than the tinny canopies of Kiev. Near the approach to Slavutych itself, one of the stops had been given the full treatment, with decorative, polychrome mosaics slathered over its surface. These two short journeys reveal something distinct about Soviet bus stops: that particular structures are placed where they are for a reason. They are, in many cases, the products of an act of concerted planning, designed as part of a new road infrastructure to provide a sense of occasion and place.

It is now reasonably well known that the bus stops of the USSR in its late years were extraordinary. They appear to contradict received wisdom about the Soviet Union and the Russian Federated Soviet Republic that formed its largest and often too overbearing part. For one thing, they are rural. The landscape-image that Soviet state propaganda

pages 5–13: Design drawings by Armen Sardarov
right: Bus pavilion number BGD-A-045

4

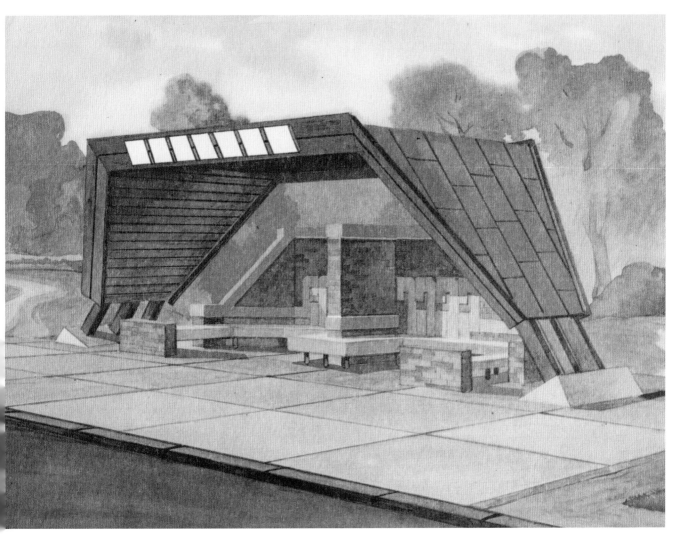

produced about itself was overwhelmingly urban and monumental – all those posters with montaged skylines of spired high-rises, concrete blocks stepping in formation, TV towers, Sputniks, factory chimneys. Even rural imagery was heavy and industrial – grain silos, tractors, combine harvesters. This propaganda was designed to showcase success in the more achievable of the Soviet state's two aims: the industrialisation of the Eurasian sprawl of the former Russian Empire, which in 1917 was largely rural, and – however much we may marvel at the high culture of old St Petersburg – largely illiterate.

Christopher Herwig's photographs of Soviet bus stops offer us images of a country that can still be very rural, even if the majority of the population has lived in towns or cities since the 1960s. Rural areas always bore the brunt of the USSR's violent dragging of the Tsarist Empire into the 20th century, from the collectivisation of agriculture and the famine it caused to the depopulation and decline of later years. These are still the poorest areas of post-Soviet Russia, their economies destroyed by the end of public subsidies and the command economy. In this context, the bus stops stand as forlorn monuments to an age when the people in high places still gave such areas some thought. But they also appear to contradict another preconception about the Soviet landscape – that it was extremely homogeneous. Everyone imagines the urban USSR as an endless series of identical concrete-panel slabs placed in vague, straggly wastelands, but these bus stops show another

side: strange and individualistic works of art sited in green landscapes, whether the flat fields that stretch from Belarus to the Urals, or the Caucasian mountains. You might deduce from this that these bus stops are a counter-architecture of some sort, a protest against the assault on place and individuality. This would be a mistake.

It makes sense to consider the bus stops within the context of the ambitious infrastructural planning commonly indulged in by the Soviet state as a means of making it publicly obvious to a sceptical population that the projected modernisation and industrialisation of the Russian Empire was actually taking place. The most famous example, quite rightly, is the Moscow Metro and its derivatives in St Petersburg, Kiev, Kharkiv, Baku, Tashkent, Minsk and elsewhere. These networks were conceived not just as commuter conduits to get people to and from work, but as a Wagnerian Gesamtkunstwerk, fusing engineering, utility, architecture and art – from the applied arts of mosaics, murals and the carving of capitals to the involvement of major figures like the painter Aleksandr Deineka – with propaganda. In the most outrageously over-ambitious parts of the system, such as the Circle Line of the Moscow Metro, the entire journey told a story, a continuous propaganda reel in which each station was dedicated to a particular part of the patriotic narrative, cobbled together from a syncretic mixture of Russian nationalism and international socialism – Alexander Nevsky, Bogdan Khmelnitsky, Pushkin, Shevchenko, the Decembrists,

the revolutions of 1905 and (both February and October) 1917, the Five Year Plans, the Great Patriotic War, and in later stations, the exploration of space.

Terminus stations were devoted to the glories of the cities and countries you were going to, with a Ukrainian, Belarusian or Central Asian theme. Transport was never just transport. Part of what made these Metro systems so successful as public spaces – though not always as transport infra-structure, since some cities, like St Petersburg, are

under-provisioned for their size, while some of the provincial systems are more ambitious than their host cities can adequately maintain – is that they were environments that could be completely controlled, right down to the air-conditioned atmosphere, so the human error and mess that always got in the way above could mostly be smoothed over. The images of bus stops show that this wasn't always possible in the countryside. Later on, attempts were made to extend the controlled approach to wider territories – as with the Baikal-Amur Mainline, a train network built under Brezhnev that stretched across a massive transcontinental space in order to connect, industrialise and populate a large swathe of the Russian-Siberian hinterland, an objective it is widely considered to have failed to fulfil. The aim of 'BAM', as it was called, was to give this entire new territory a concerted, overall look, so wherever you were within the network would be identifiable as 'the territory of BAM'. This was to be achieved through the design not only of stations but of the new towns and districts that came with them. Such controlled public transport systems would seem to make more sense within the Soviet order than the provision of motorways for private transport – but the bus stops are attempts to ensure good public planning in out-of-the-way places too.

This impression is confirmed by a decree that could be considered foundational in the design of these

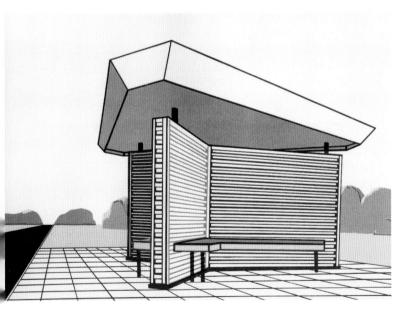

Bus pavilion number MODS-10/79-A

structures. The Ministry of Transport Construction's State-Union Road-Scientific Research Institute's 'Methodical Recommendations for the Design of Bus Stops', published in 1975, is mostly devoted to issues you would expect to address anywhere – the placing of stops, their safety, their economical construction, and the provision of toilets, which are mostly conspicuous by their absence. But then a few clauses about design appear. 'The design of bus stops', it asserts, 'should pay special attention to modern architectural design, in accordance with the climate and the local and national characteristics of the area. Bus stops should be the compositional centres of the architectural ensemble of the road. The planning solutions for bus stops, the design of pavilions, the elements of exterior trim, small architectural forms, landscaping and lighting should be compositionally combined with the surrounding environment.' So rather than being the crazed experiments of architects doing wild things when they believed Moscow wasn't looking, bus stop architecture can be seen as the direct result of a governmental decree. From the evidence of these photographs, the edicts were extraordinarily successful, enabling a remarkable flourishing of local colour and, in the parlance, 'national form', with individual structures usually very distinct in accordance with the places where they are sited.

The phrase 'small architectural forms' refers to a systematised catalogue of lightweight concrete pavilions published in the Ukrainian Soviet Socialist Republic in 1971 (other 'small forms' include beach pavilions, children's playgrounds, shelters in nature reserves, and so on). The architectural influences are not hard to spot – these concrete-shell structures derive from the mid-century sculptural experiments in the economical use of concrete by engineers such as Félix Candela and Pier Luigi Nervi. In the US, this became the 'Googie' style, famous for its use in roadside diners and motels that needed to catch an eye moving at speed; by the early 1970s, the style was largely considered out-moded outside the USSR. However, this is exactly the architecture that early Postmodernists Robert Venturi, Denise Scott Brown and Steven Izenour celebrated in their 1972 book *Learning from Las Vegas*, in which they praised qualities such as comprehensibility, colourfulness, mundanity, commercialism and kitsch that highbrow critics derided within roadside architecture. They divided such buildings into 'decorated sheds', where the sign is more important than the structure, and 'ducks', or stand-alone sculptural objects. Soviet bus stops are nearly all ducks. Some are even in the shape of birds (pages 116–117).

Just as we would be wrong to assume that the outpouring of creativity embodied in the bus stops was aimed against the system rather than its direct consequence, so we would also be wrong to think that the architects responsible did not know what they were doing. Belarusian architect and bus stop specialist Armen Sardarov's account shows him to have been in close touch with American and Western

European design, which he combined with a deeply Soviet approach to planning and propaganda. 'As soon as I graduated from the Belarusian Polytechnic Institute as an architect', he told Christopher Herwig, 'I suggested making a scientific thesis dedicated to the topic of road architecture. It was unusual, it was, so to say, dramatic for this place, and a number of people were rather sceptical about it, but Belarusian road workers supported me a lot. They said, "Yes, OK, let an architect take care of our roads, we want our roads to be beautiful."' The process obviously entailed finding out what was there already. 'There are historic roads with very beautiful pavements, with parkways, with old post houses, crosses, road signs, small roadside chapels, bridges. All this had never been described before. I made a description and included it in the historic part of my thesis.'

The ambition to make Belarusian roads 'interesting and beautiful' was supported by studies of the American experience – where there had been 'an idea of beautiful roads, of motorways and parkways' – and also, even more controversially, of the design of the German Autobahn, where roads were considered 'not just like a line on the map, but as a spatial system'. The main American inspiration was Kevin Lynch, a writer and critic of monolithic planning, and in particular his seminal 1965 text *The View from the Road*. Here, Sardarov recognised that, 'passing along the road should leave an artistic image, like a piece of art. I dedicated a big part of my life to this, including through bus stops. There were ideas in Lynch and the Germans that there was a system where a road symbolised two incarnations – space and time.' But Sardarov intended to go further, 'not only to analyse the system we see from the road, but to offer an idea that a road itself, a road can be some complete architectonic creation, a work of art.'

As this rhetoric demonstrates, the bus stops were conscious creations that were intended to be seen

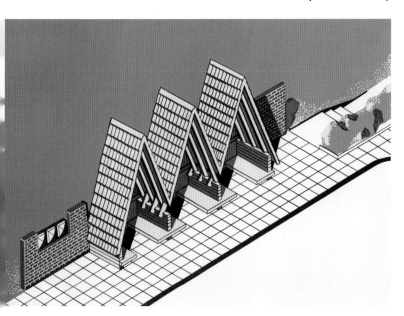

Bus pavilion number AM-11-23

as such – literally, 'to change people's consciousness'. Typically for the post-Stalin USSR, ideas were drawn from cybernetics, but attempts were made to humanise this austere discipline – in Sardarov's words, 'to focus on a human being, on a person, on his psychology. We know it is individual for each person, and it is individual for each ethnicity, it depends on the mentality, and it is impossible to express everything with mathematical language.' In practice, this meant, for instance, that in designing stops in the Belarusian Republic, he would consider local materials: 'Belarusian architecture is mostly made of wood and stone, not artificial stone, but the ones that were collected on the fields. There are lots of stones like that here, because… when the glacier withdrew, in the Ice Age, it left lots of stones behind.'

It wasn't just local materials, however, but also the – heavily propagandistic – local narratives that were important. Bus stops in one area were designed to draw on the work of poet Yakub Kolas, who collaborated with local naive artists to decorate the stops with motifs drawn from folk art, so that 'each one has individuality'. Something similar was achieved in a series of stops devoted to Felix Dzerzhinsky, the founder of the secret police. 'There are some sharp forms, which slightly recall his nature, because he was called Iron Felix. And there is a sign there, iron is a sign, and it recalls a sword plunged into the ground. If you go there, you will be able to

Bus pavilion number BDG-A-083

see the sword, it still exists. I had no opposition and they supported me, so I made this road, which leads to the motherland of Dzerzhinsky. That is what the idea of Dzerzhinsky was. Oh, beautiful!'

A similar story steered the design of bus stops in the nearby Lithuanian Soviet Socialist Republic. Here, Vilnius-based architect Konstantinas Jakovlevas-Mateckis produced stops for the highway between Vilnius and Kaunas, the second-largest city and 'temporary capital' during the interwar years.

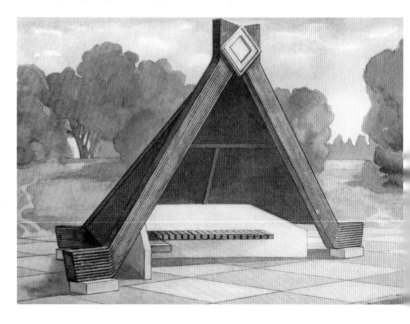

According to Jakovlevas-Mateckis, there were 'different bus stops but in the same style, made of factory-produced elements which were manufactured at our Vilnius factory of reinforced-concrete goods'. When asked whether making the unique range of bus stops was a break from the monotony of Soviet architecture, he replied: 'You could say so, yes, because they were in such a modern style, they were very innovative for that time.' However, his justifications for producing designs that were specific to this particular highway were similar to those put forward by Sardarov – this road was to be a concerted ensemble, linking landscape, architecture and engineering: 'We wanted this highway, this first well-ordered, landscaped highway, to be the face of two capitals: Vilnius and Kaunas.' So here we have something which is both 'individual' and deeply propagandistic, intended as the 'face' of an area, to tell a story about it and to give it an identity – just as with the Metro or BAM.

As there too, the scheme was rolled out through a form of mass production. Bus stops may not have been standardised in the same completely repetitious way as the monolithic mass housing, but they were certainly mass produced. As Sardarov points out: 'Not every architect can boast that he has 10,000 objects. I can say that I have 10,000 or 15,000 objects – they are very small, but they were repeated in huge amounts and crowded all our roads.' Yet at the same time, their design set out to achieve 'individuality in architecture, to try and withdraw from mass production, from brutality to some individuality'. This is only apparently a contradiction.

It is true that this was not 'high' architecture. The major designers in Moscow, the masters of prestige projects and the heads of the architects' union, such as Mikhail Posokhin, Felix Novikov or Leonid Pavlov, did not concern themselves with it. St Petersburg architect Olga Ushakova remembers many of the

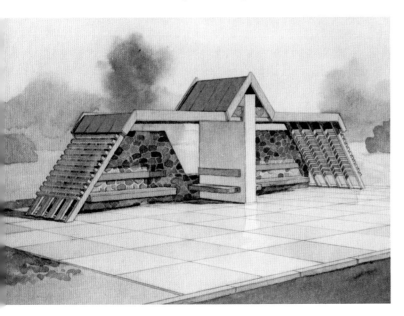

Bus pavilion number BDG-A-077

bus stops being the product of student projects, essentially a form of training: 'as a sophomore every architecture student designed a bus stop', along with other 'small architectural forms' such as children's playgrounds. Unusually, these would actually get built. This was 'pretty creative work, rather unexpected – they were required to find new, creative solutions. They could not repeat themselves.' Students would work on site, building as well as designing. But, again, this is not because the state was uninterested – in fact, it was quite the reverse. The stops 'were located on such important highways, and it was such a brand of the district or brand of the region. And everyone tried to prove oneself.'

As Ushakova points out, one means of creative expression was engagement with local materials – never a Soviet strong point, but mandated in the 1975 recommendations. 'For instance, here, in the Urals, bus stops were made of wood', anchored by 'a concrete foundation', but with 'an interesting wooden roof of a modern design'. At the same time, 'they were certainly bearing a propaganda component' that reflected the 'ideological component' of committing expenditure to public transport in rural areas far from the glories of the urban Metro stations: 'public transportation as a very important component in the life of the Soviet society'. Ushakova argues that as a result, 'people met at the bus stop, they talked, they exchanged ideas, it was really a social place'. Any 'restrictions' on design were 'just common sense', such as stability or visibility from afar. But this was

not a free for all: it 'was not that one bus stop was made differently from another. The intention was to build the highway in the same style.'

A taxonomy of the results could be produced – for each republic and oblast, for each new highway and rural district – to make clear the concept and landscape each set of bus stops was meant to proclaim. Construction worker Sergei Verbitskii, who worked on bus stops in Moldova in the 1980s, points out that because they were the responsibility of individual districts rather than the higher-level leadership of the republics, the stops were designed by local district architects, who could 'recruit their local artists and local craftsmen'. The shells might be standard, but in the execution, 'everyone on the spot invented something of their own' – a freedom that was seldom possible, or, due to the rush to meet targets, seldom offered, in housing design. But Verbitskii is unconvinced that these apparently personal and individual designs embodied any kind of protest or dissent. Yes, 'decoration and everything else was done on the spot', but 'to look for a protest in that, I think, is not necessary'. If anything, it was the opposite: 'Bus stops were one of the places of public assembly, where people gathered and departed and arrived. They were likely to be one of the points of the ideological system.' So these were outposts of ideology in the most obscure places, inculcating Soviet values – the importance of equality and public provision, the 'national tradition' of a particular part of this alleged brotherhood of nations, and the

sweeping up of even the most far-flung places into a concerted national story.

Sometimes, this is explicit. In some of the bus stops in this book you can see straightforward propaganda imagery – workers and peasants, male and female cosmonauts bringing the achievements of the Soviet state to places where space flight must have seemed spectacularly improbable. Elsewhere, the message is a little more subtle, evoking the new technologies that were being brought to the villages – in one bizarre example, the bus stop is in a bulbous structure shaped like a turnip, which on close inspection proves to be a lightbulb, in which you can sit and wait (pages 30–31). In some instances, the story has moved on a little – a few concrete pavilions are painted in the red, white and blue of the Russian Federation flag, and one concrete shell has a huge statue of St George slaying the dragon perched precipitously on its edge (page 51), in the hyper-kitsch traditionalist style beloved of the Russian 1990s and 2000s (though as that style has deep Soviet roots, it could just as easily be pre-1991). But this is largely a Soviet story, and no bus stops in the last 26 years have tried to emulate it, for all the nostalgia with which the Soviet past is (often dubiously) remembered.

It is worth recalling, as you look at these bus stops, that they are not a freak accident that emerged because people were desperate to escape the grimness of Soviet reality. Rather, you are looking at a product of the Soviet system, with its combination of command economics, public provision and a paradoxical bureaucratic chaos, where apparent conformity and regularity were bent and twisted at the edges. These bus stops are every bit as Soviet as the bleakly monolithic concrete housing blocks and crumbling factories: the Soviet state with a human face, clever little sculptures that represent the only obvious monuments to the planned industrial economy in the deepest reaches of the countryside.

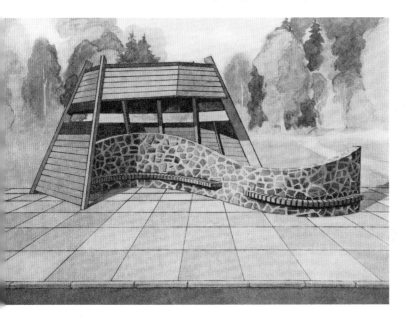

Bus pavilion number BDG-A-105

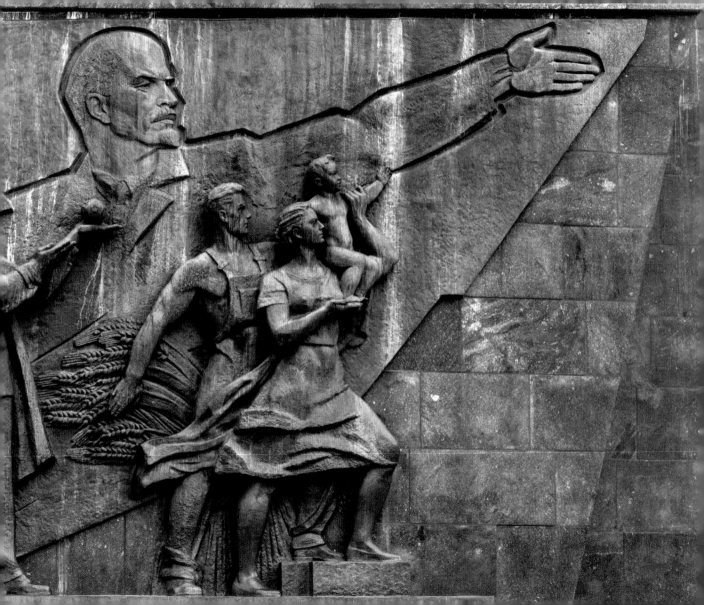

Automotive Electrical Equipment Plant, Stary Oskol, RUSSIA

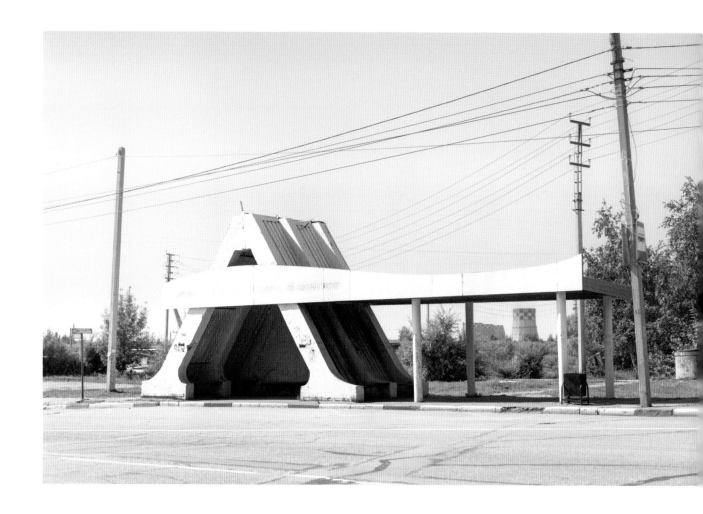

Dairy Works, Blagoveshchensk, RUSSIA

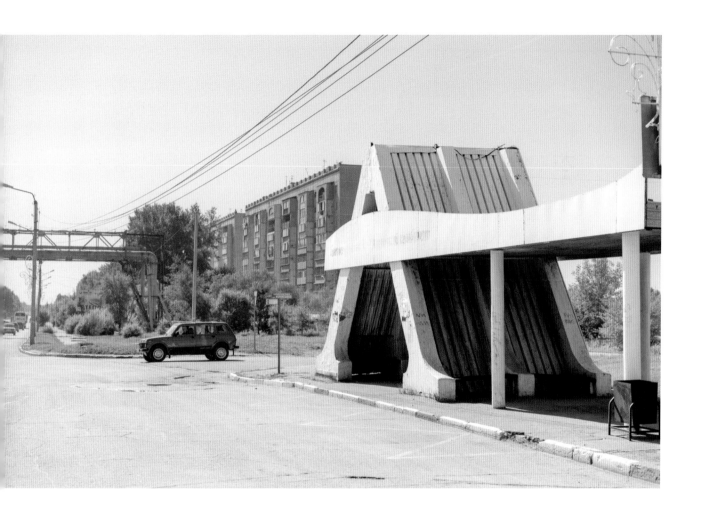

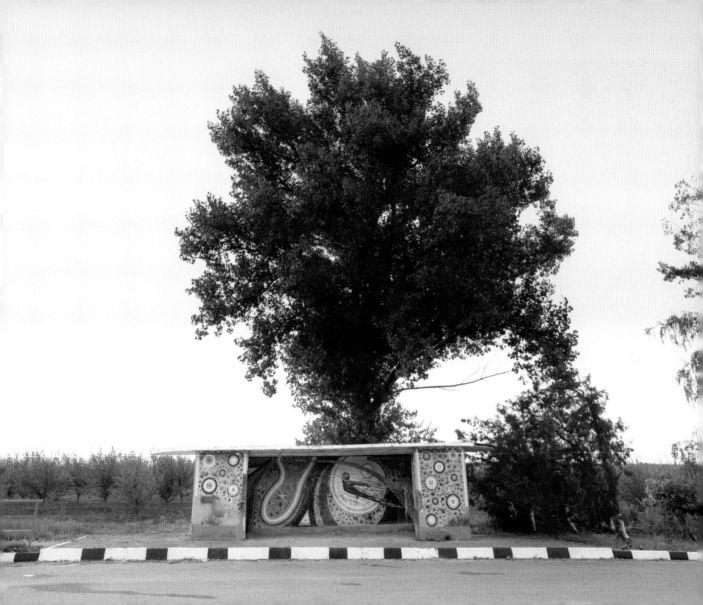

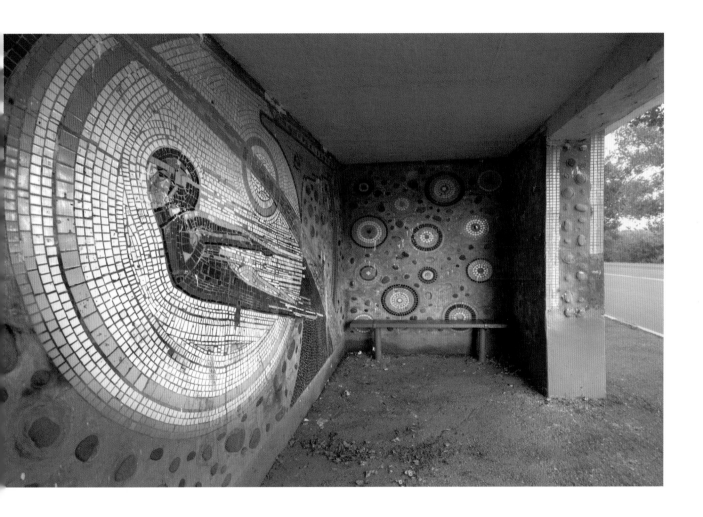

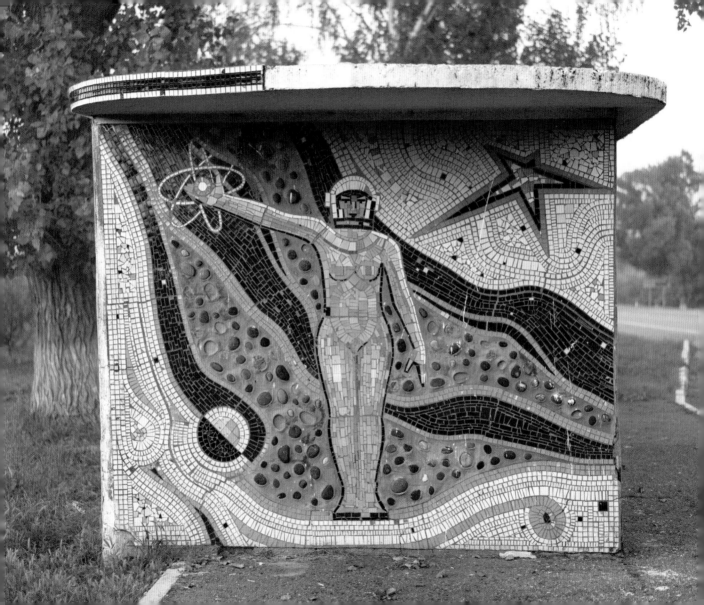

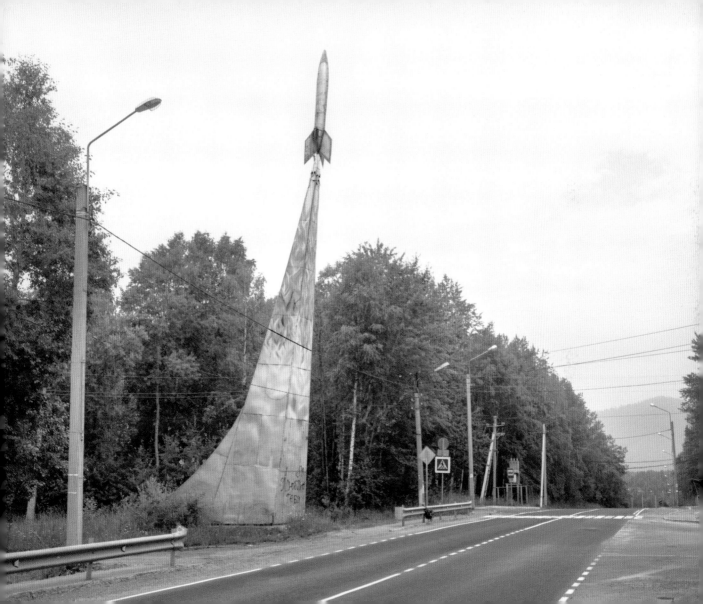

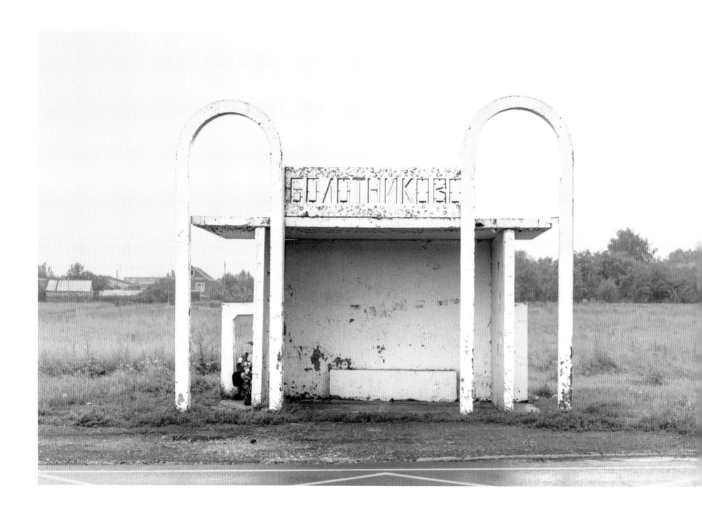

Bolotnikovo, RUSSIA

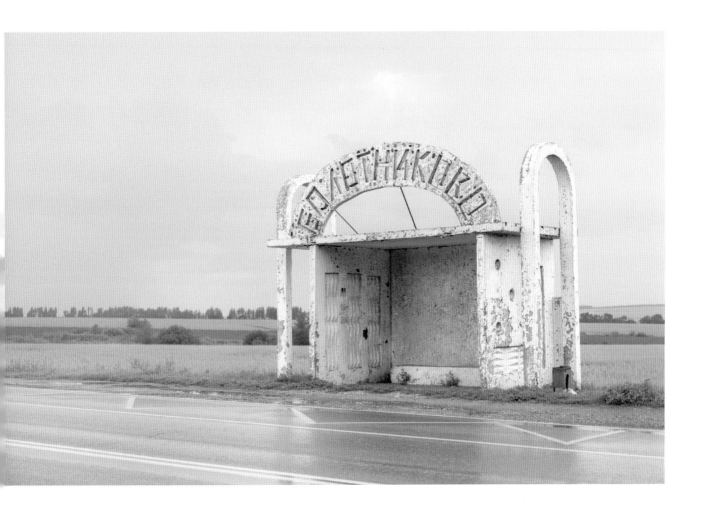

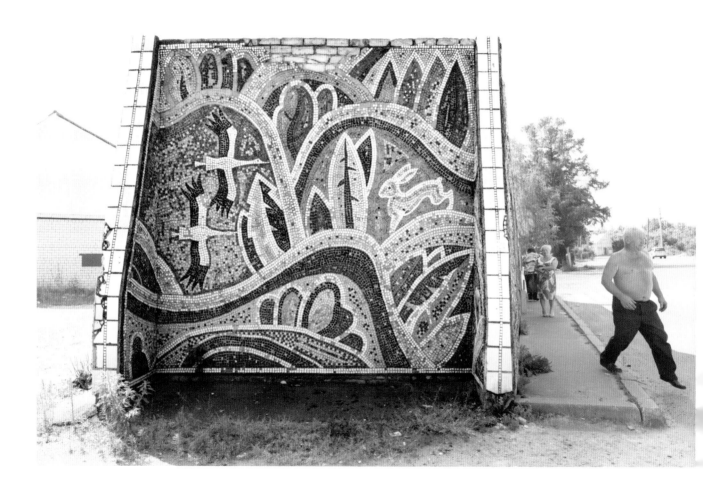

Kuyar, RUSSIA

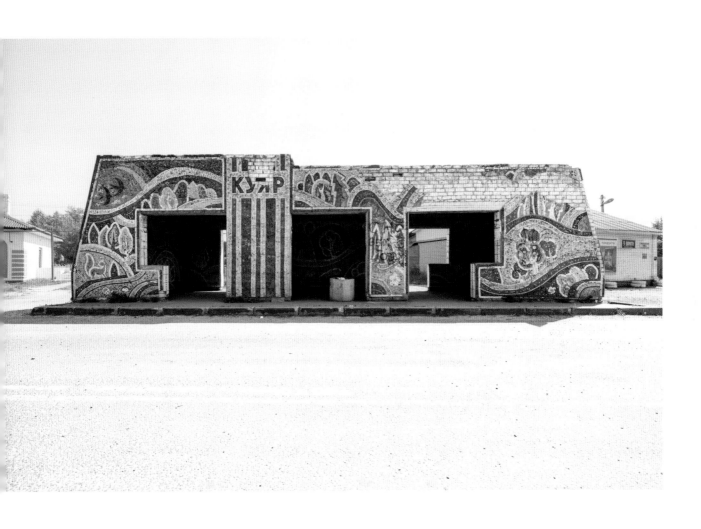

27

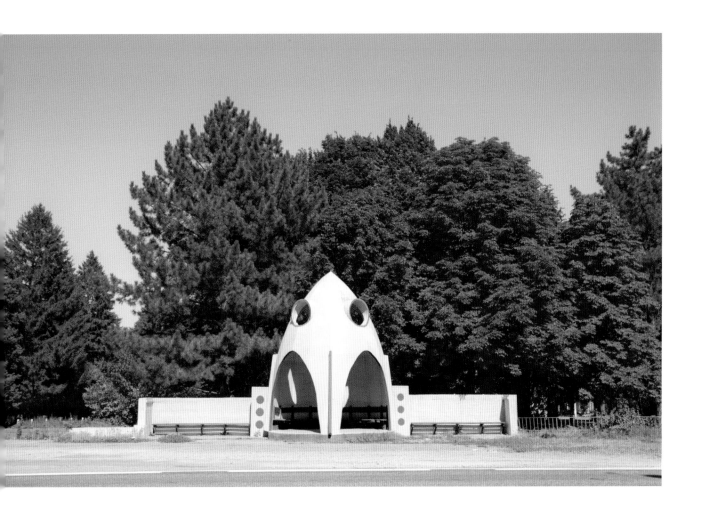

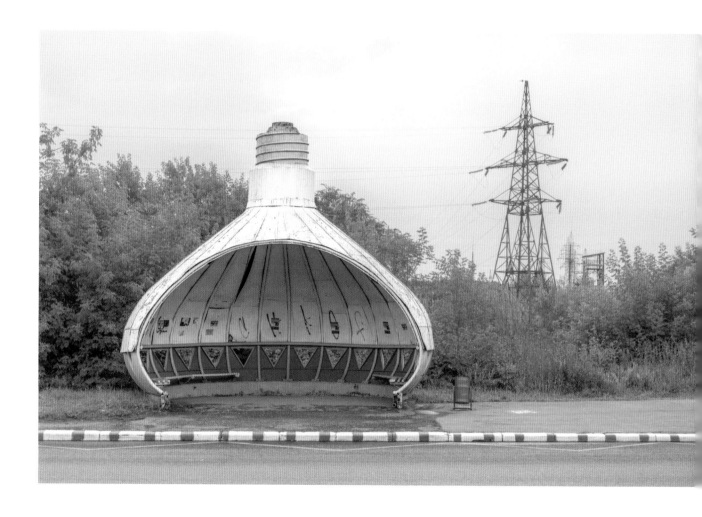

Saransk, RUSSIA

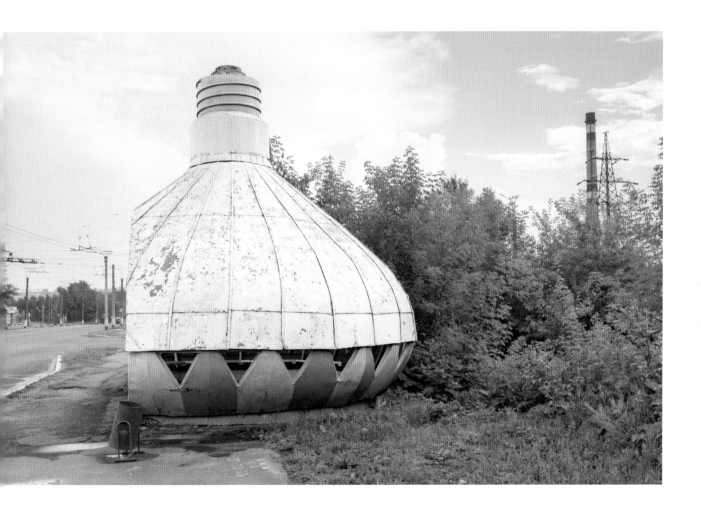

verleaf: Naberezhnye Chelny, RUSSIA

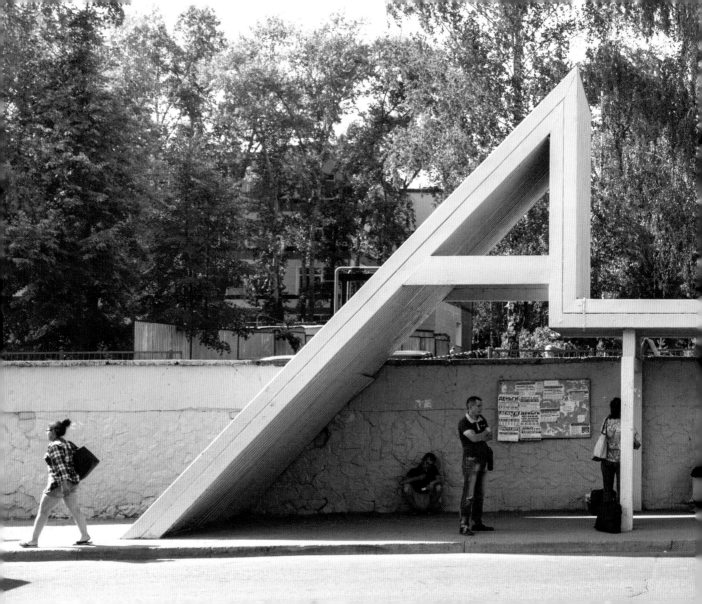

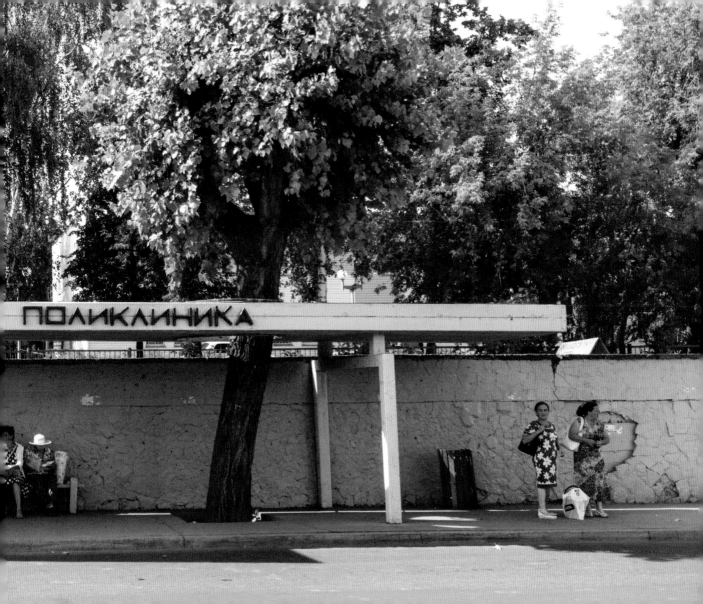

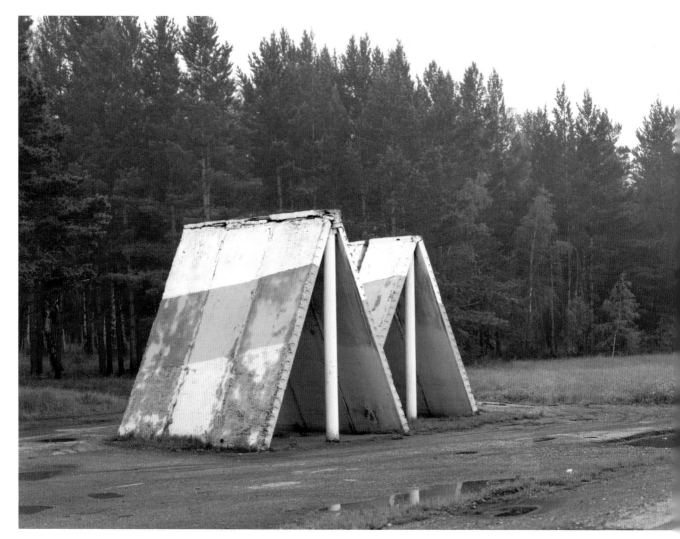

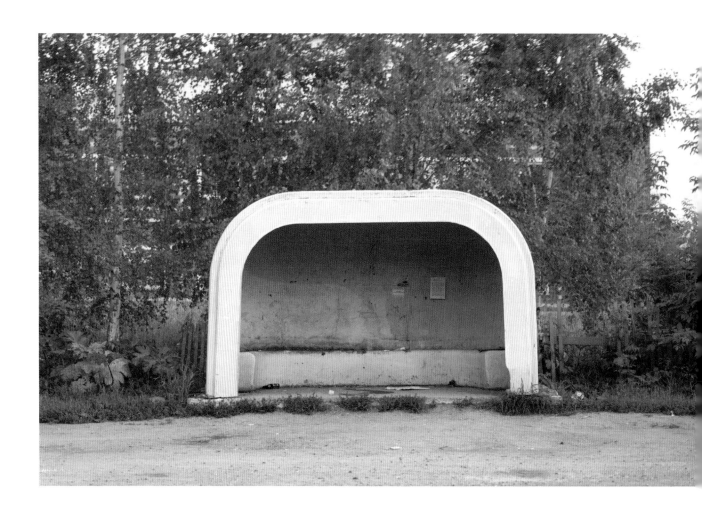

Sandugach, RUSSIA

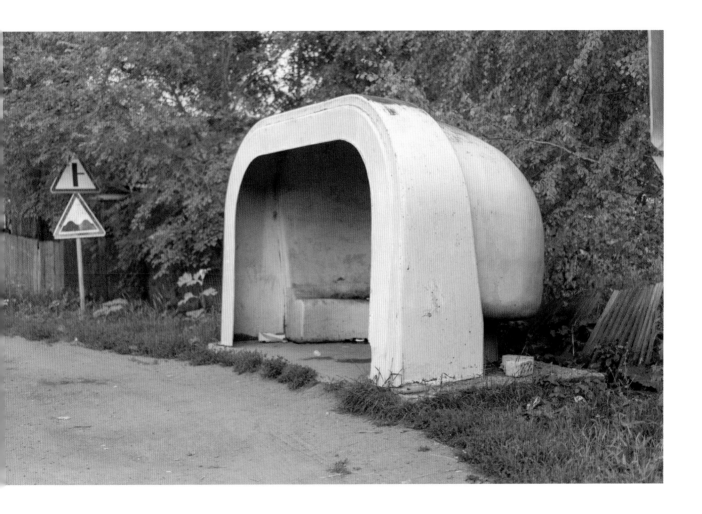

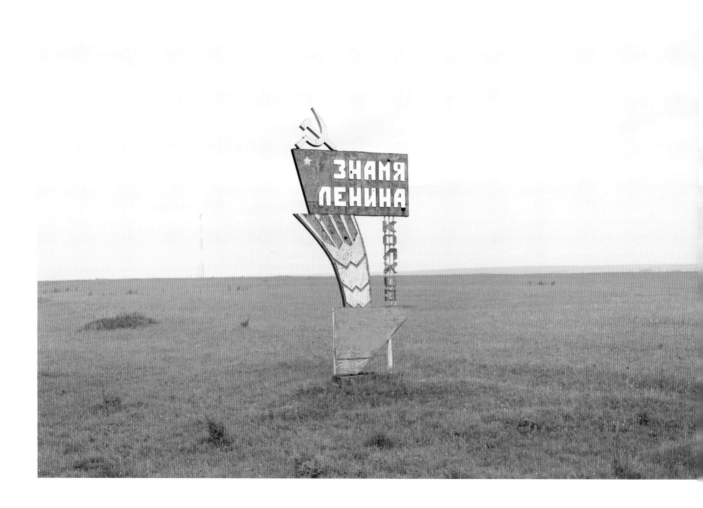

Lenin Collective Farm, Isetskoye, RUSSIA

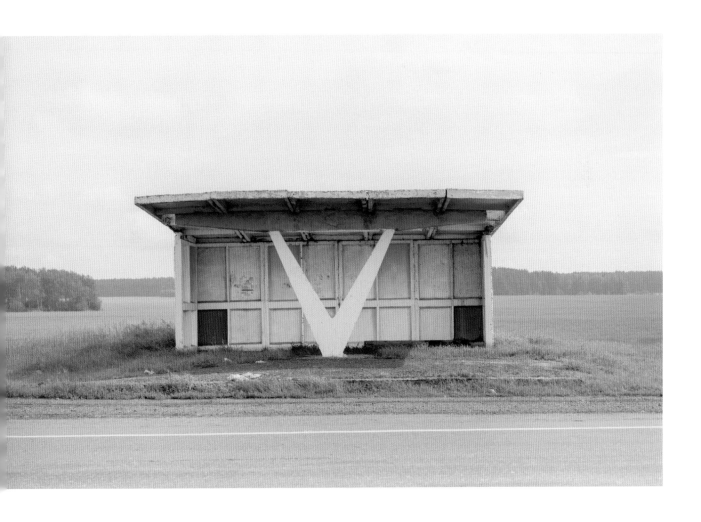

Shadrinsk, RUSSIA 39

Vitaly, bus driver, Barabinsk, RUSSIA

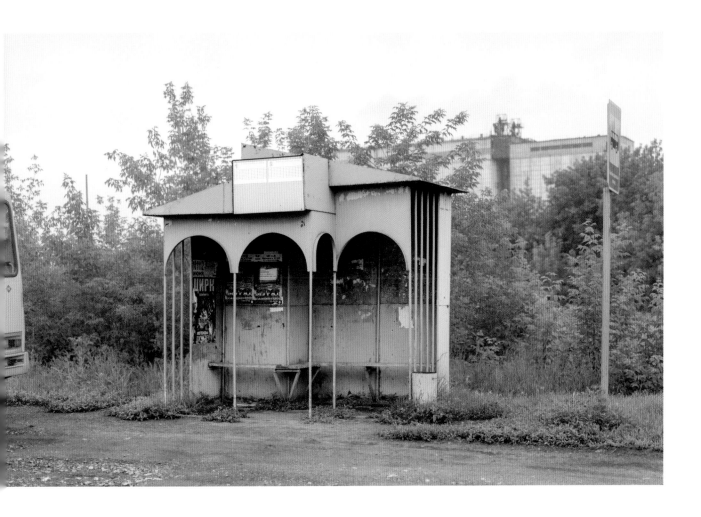

Animal Feed Factory, Barabinskiy, RUSSIA 41

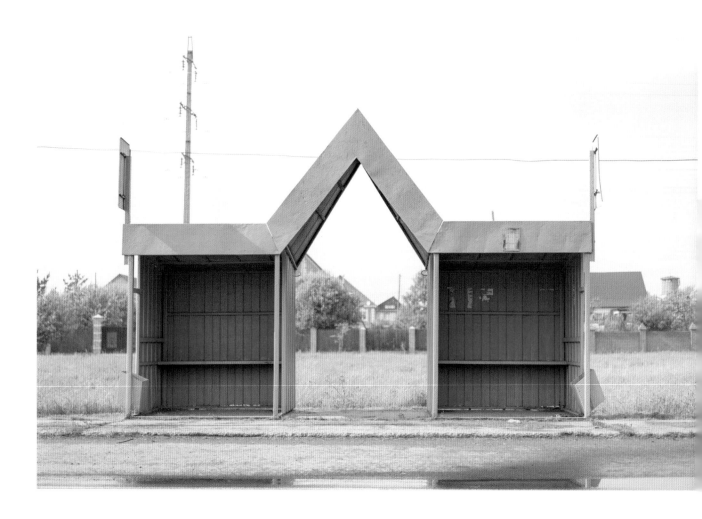

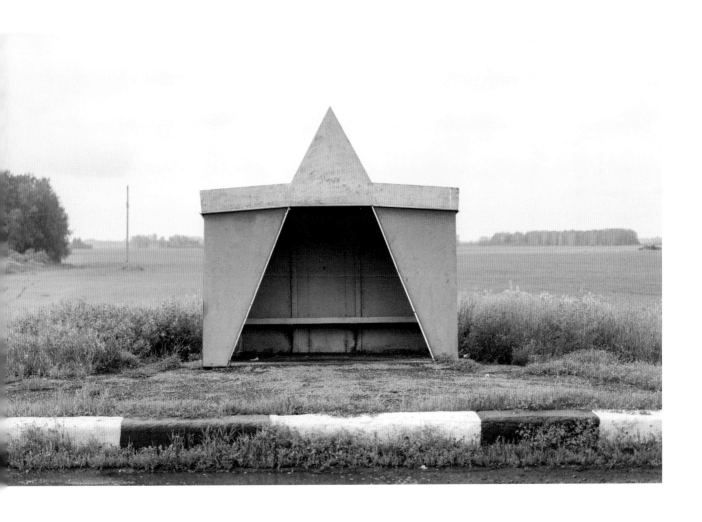

44 Udinsk, RUSSIA

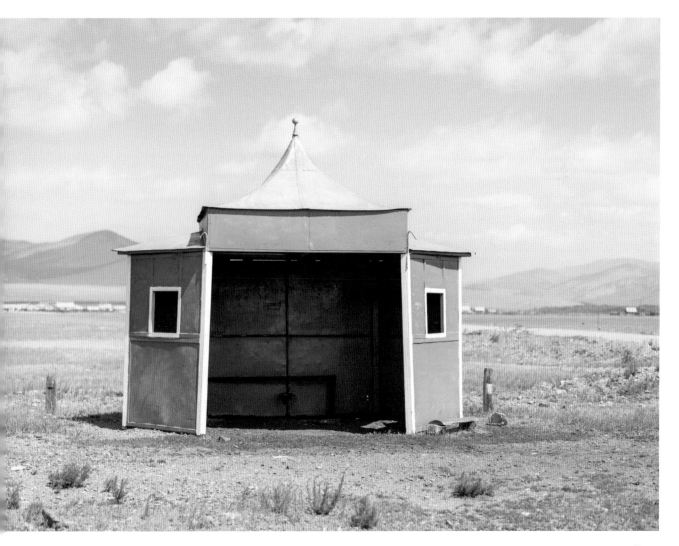

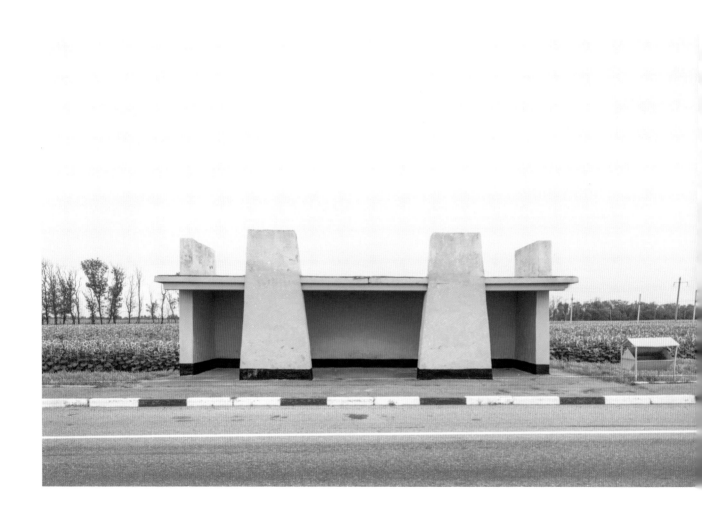

46 Armavir, RUSSIA

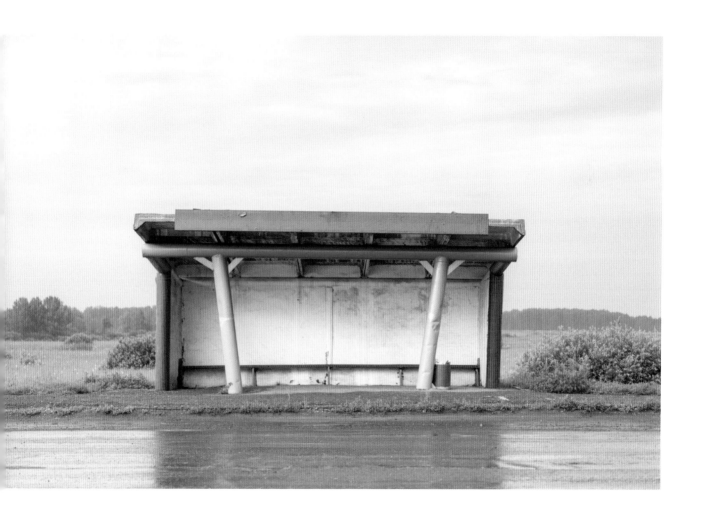

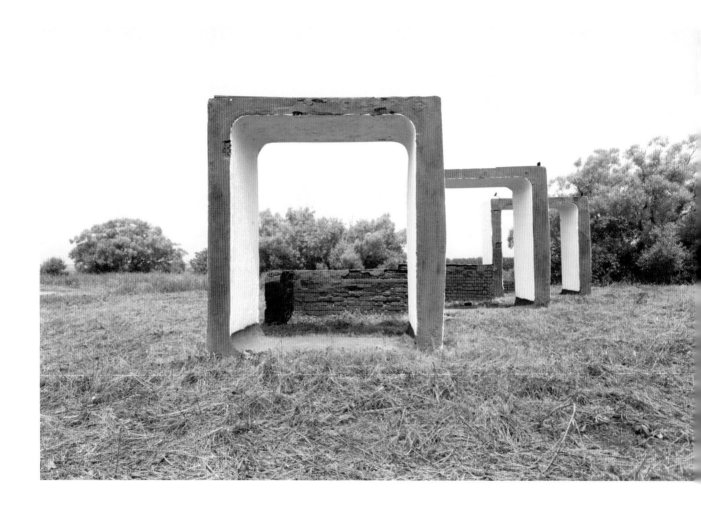

Ermolovka, RUSSIA

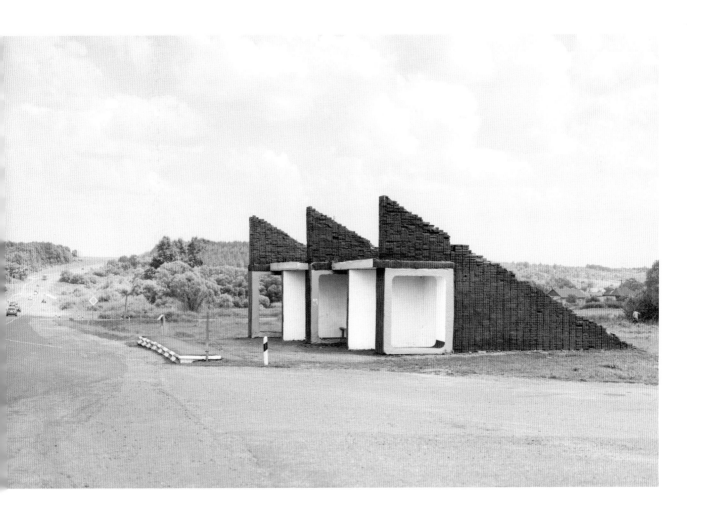

Zagoskino, Russia 49

Aleesha, Rostovanovskoye, RUSSIA

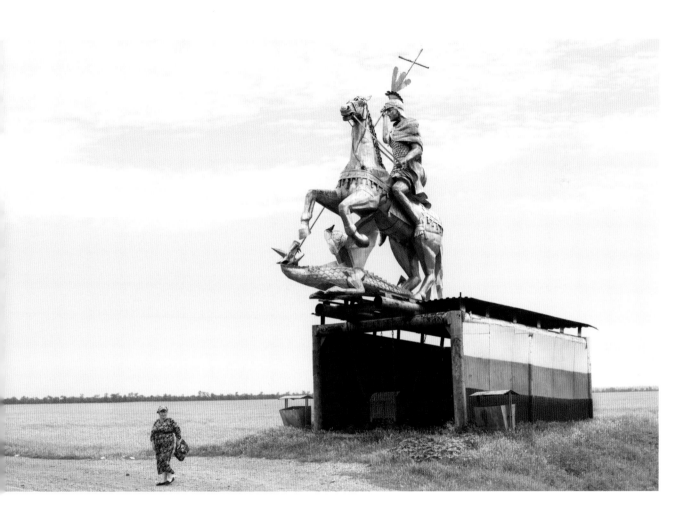

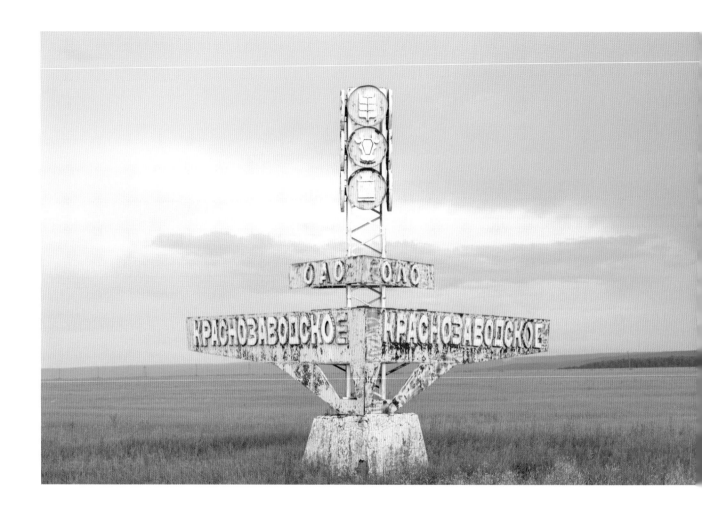

52 Kritovo, RUSSIA

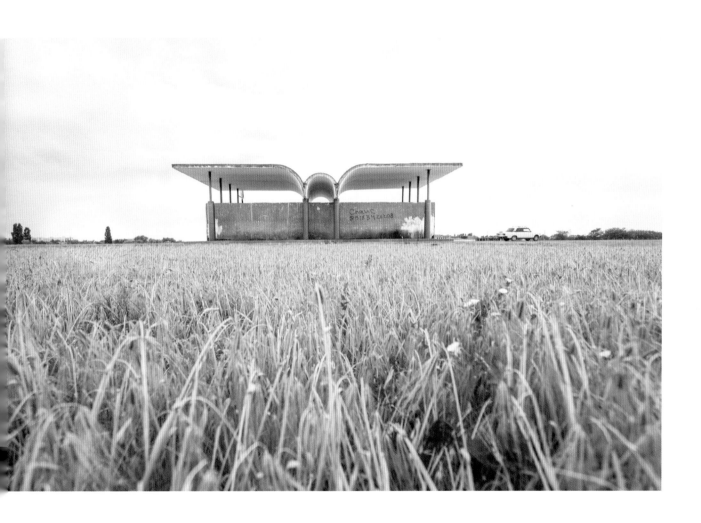

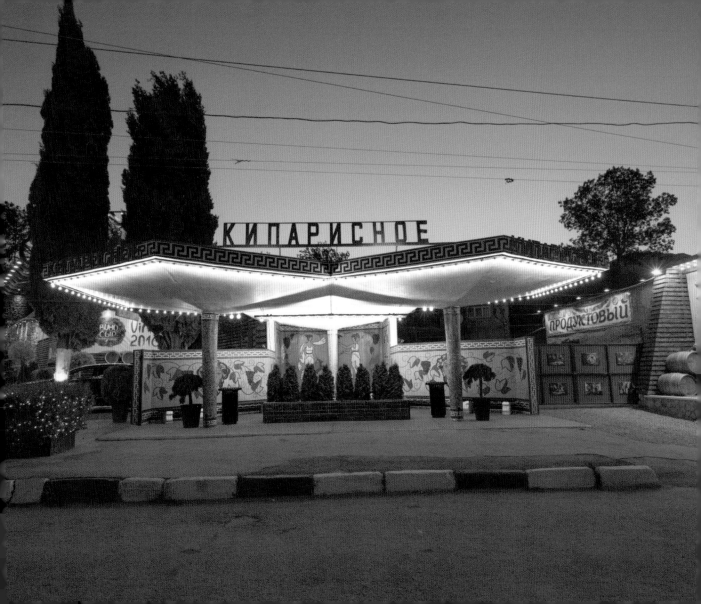

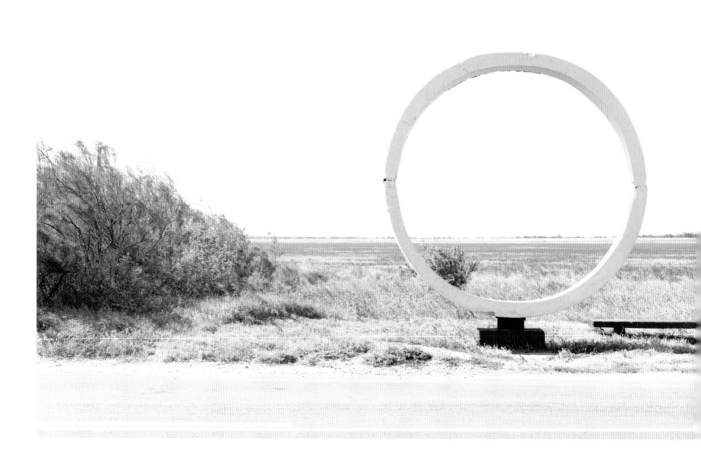

56 Luhove, CRIMEA

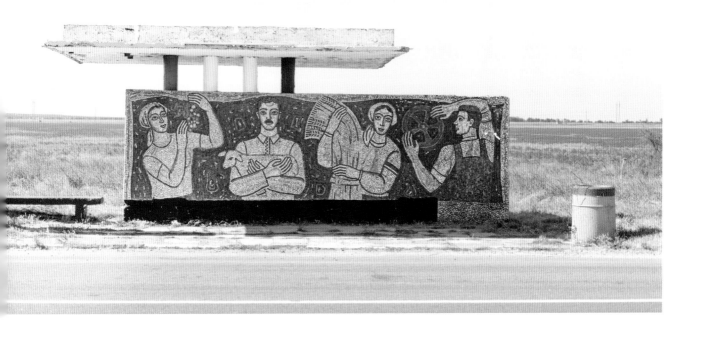

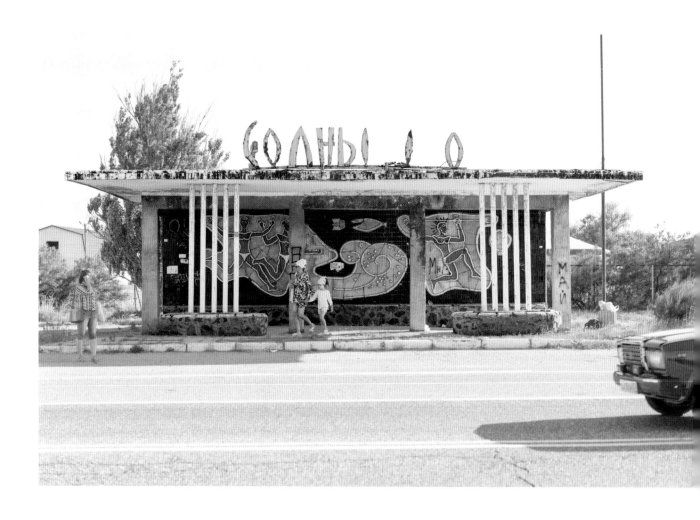

Yevpatoriya, CRIMEA

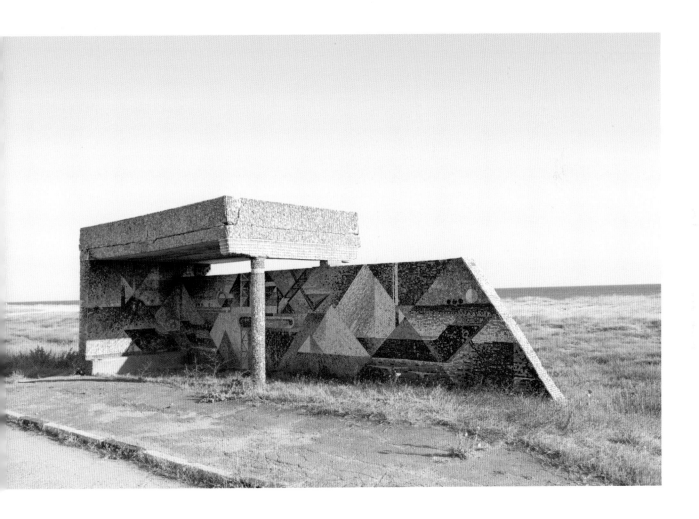

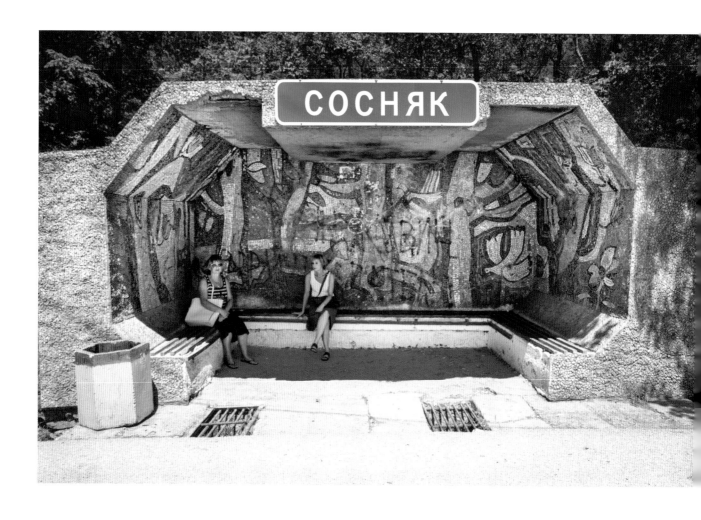

Sosniak Sanatorium, CRIMEA

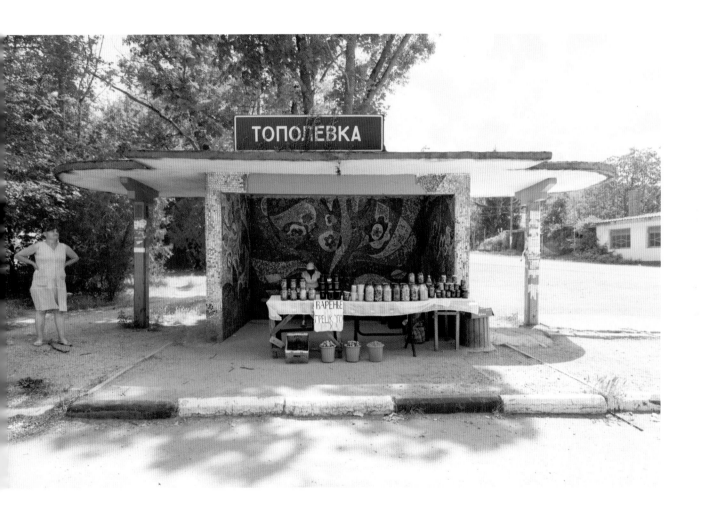

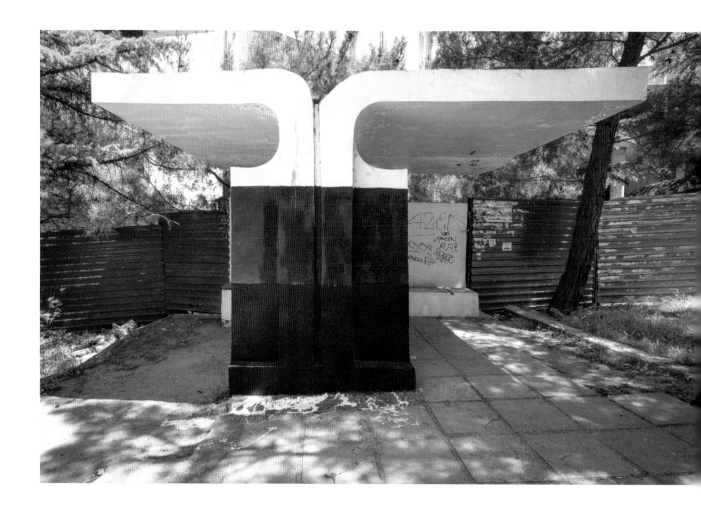

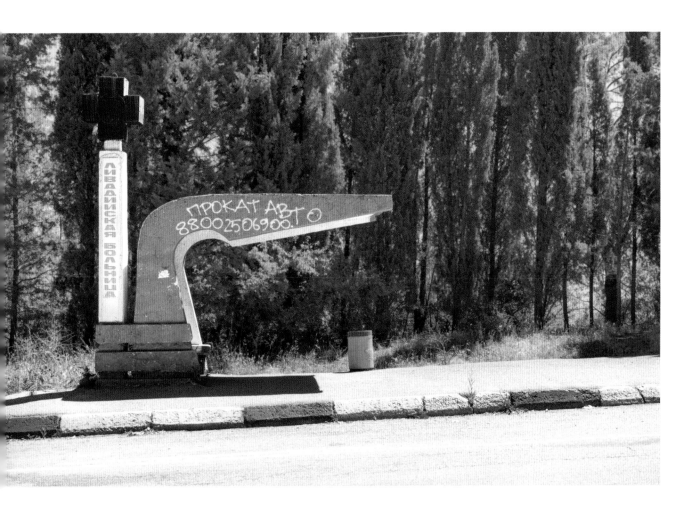

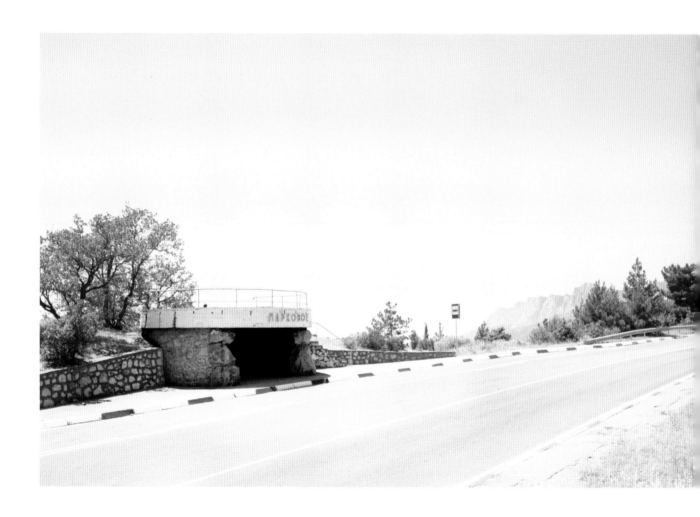

64 Parkove, CRIMEA

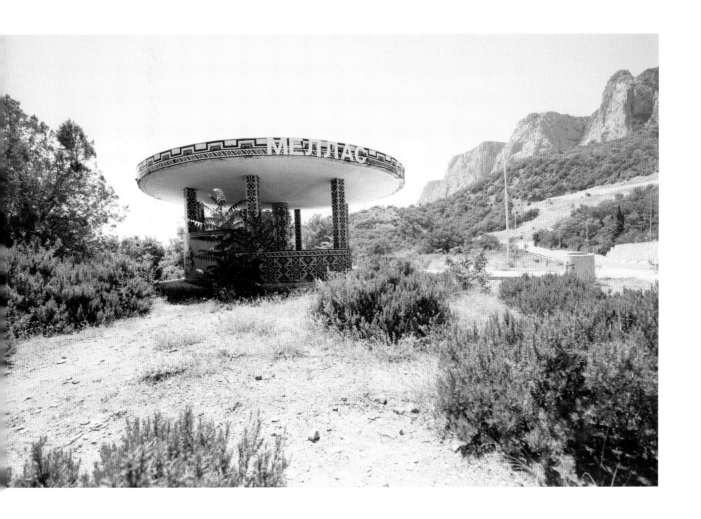

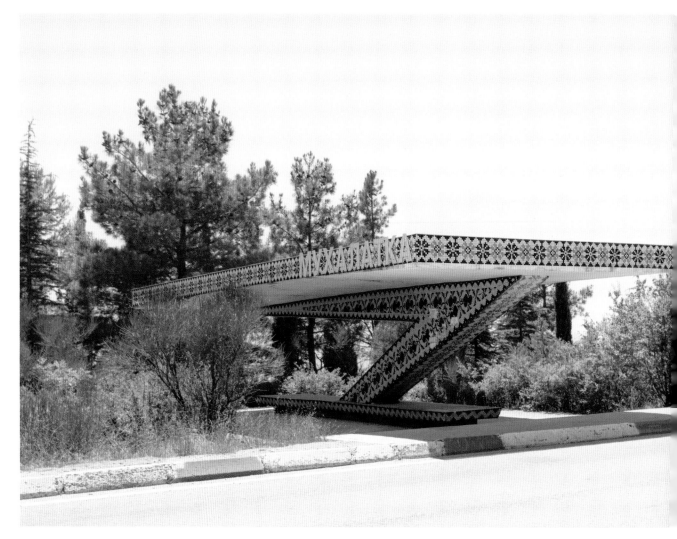

66 Mukhalatka, CRIMEA

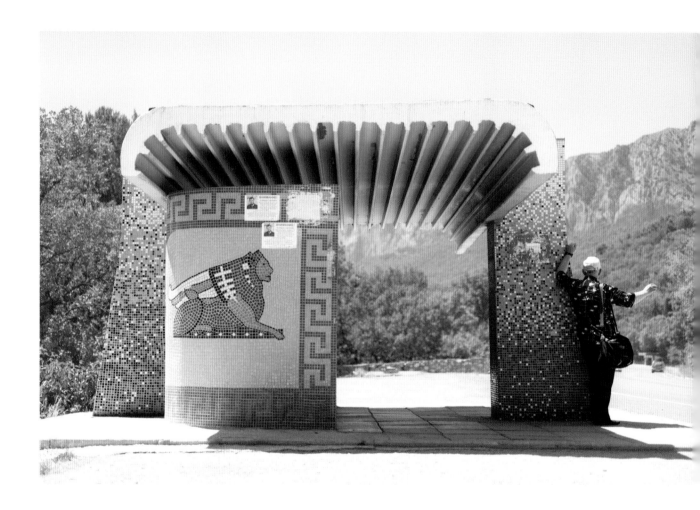

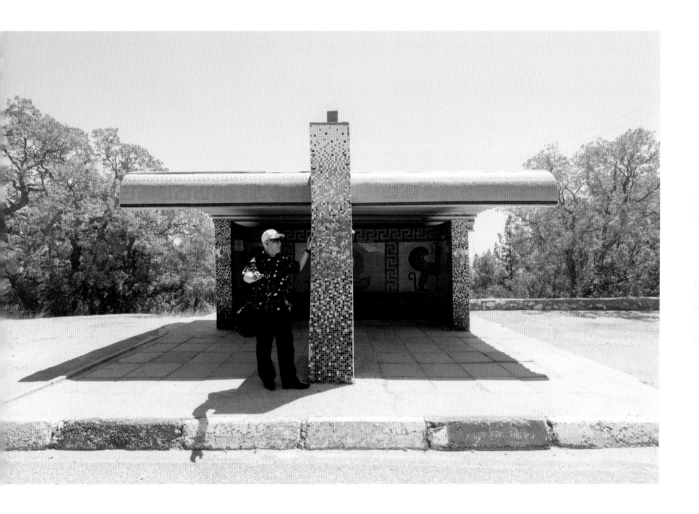

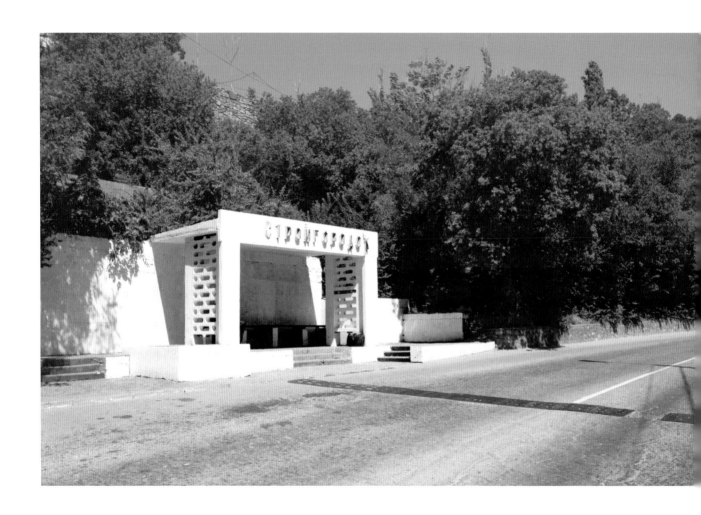

Stroy Gorodok, CRIMEA

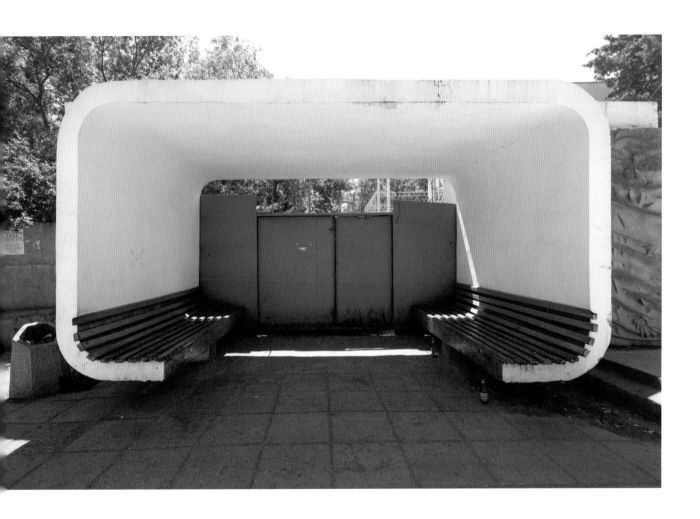

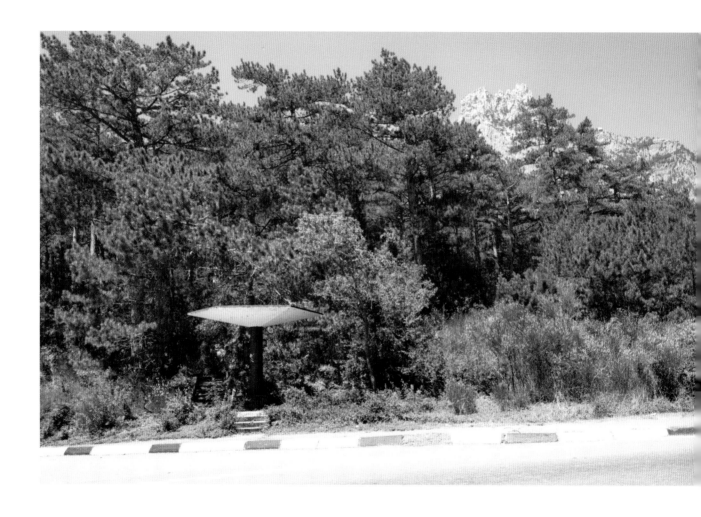

Alupka, CRIMEA

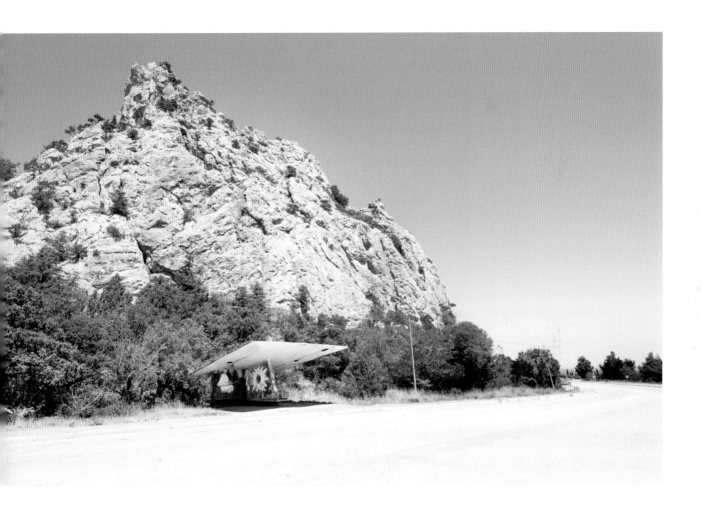

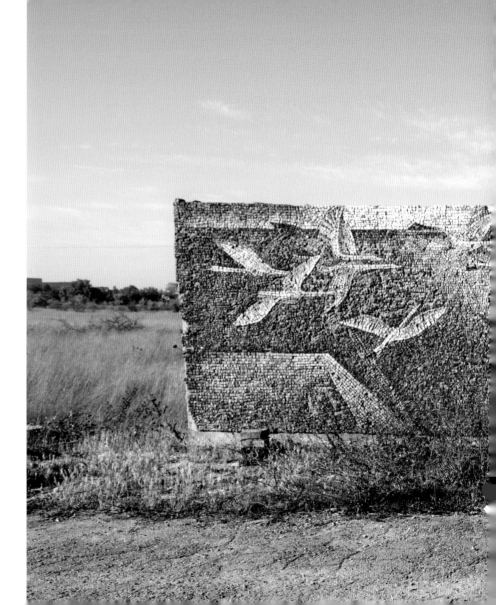

74 Saky, CRIMEA

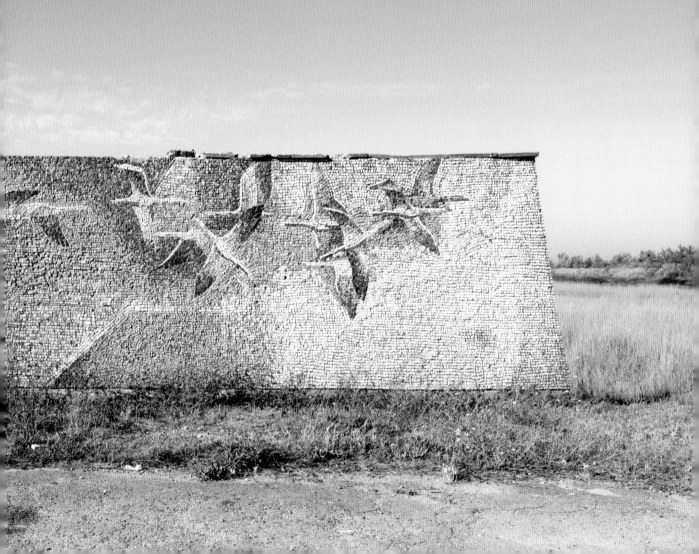

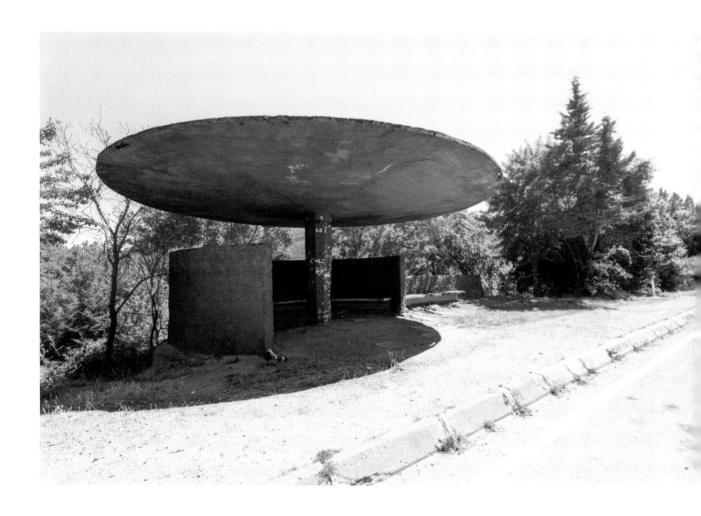

Honcharne, CRIMEA

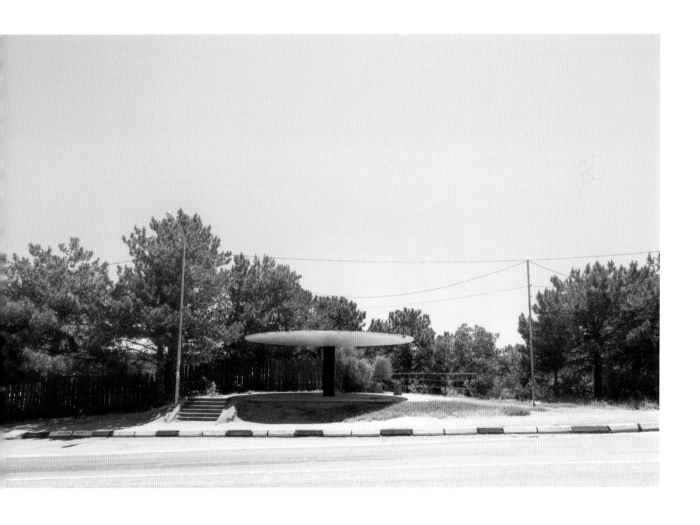

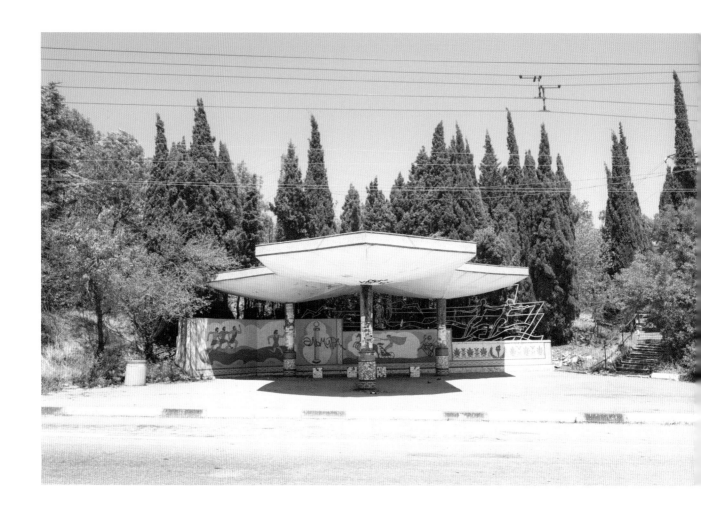

Krasnokam'yanka, CRIMEA

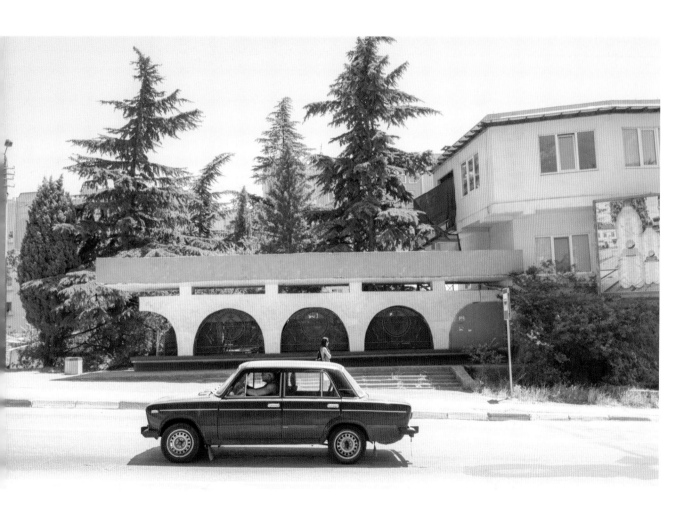

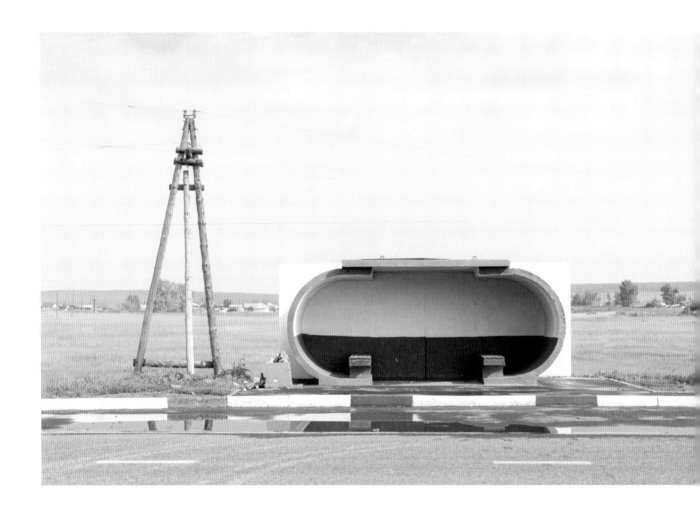

80 Rybnoye, RUSSIA

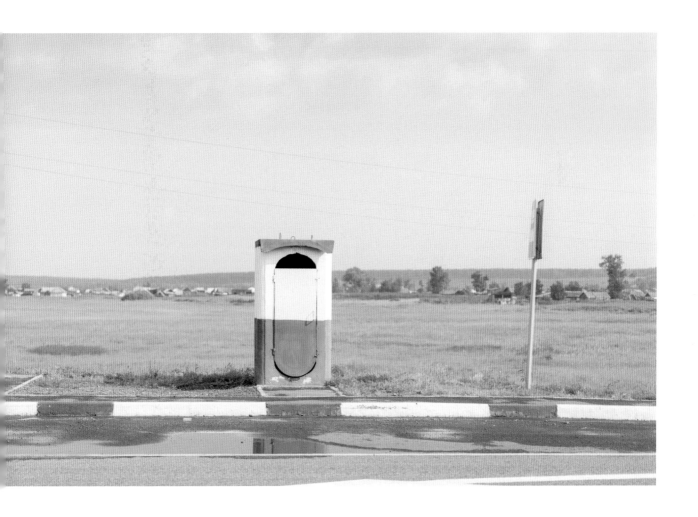

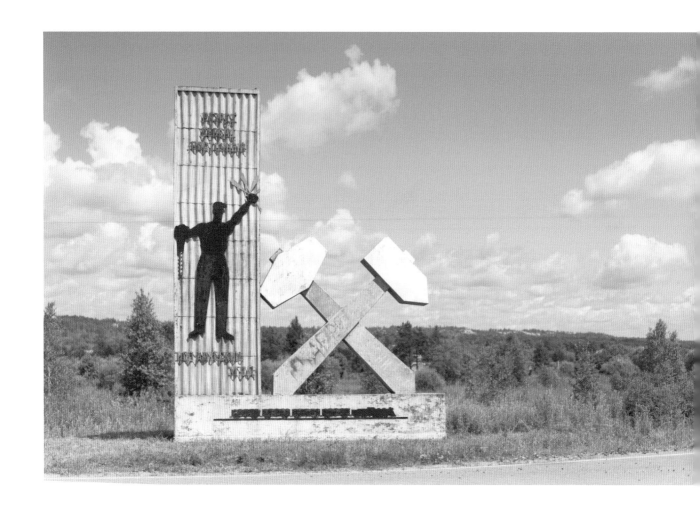

Shirokiy, RUSSIA

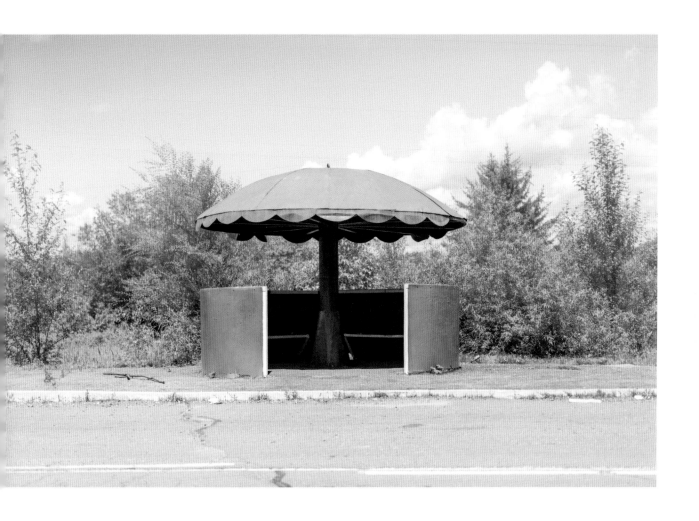

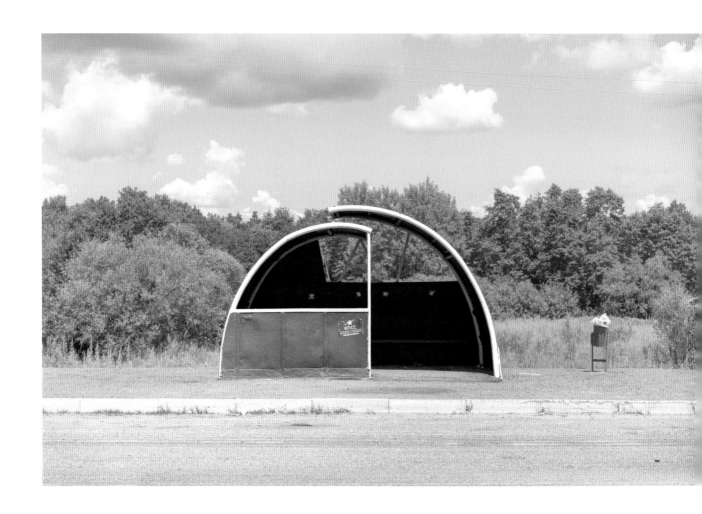

Staraya Raychikha, RUSSIA

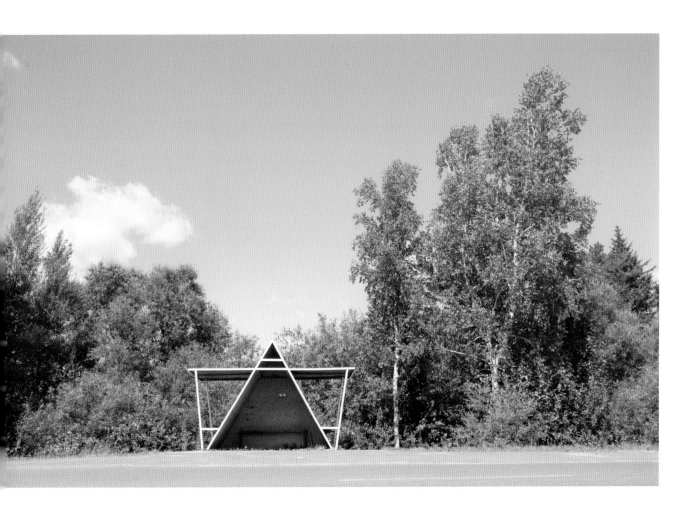

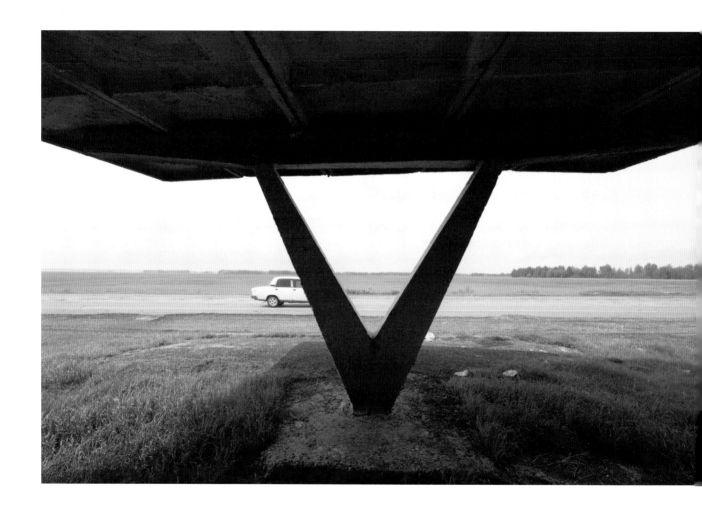

86 Shadrinsk, RUSSIA

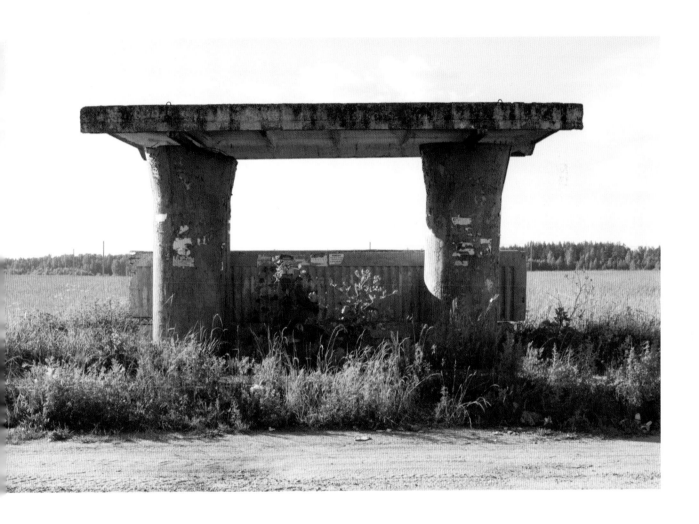

Ksenia, Omsk, RUSSIA

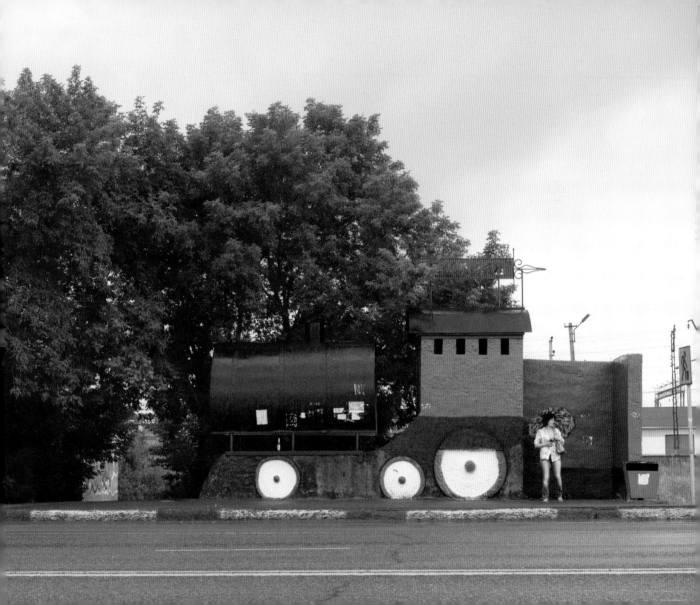

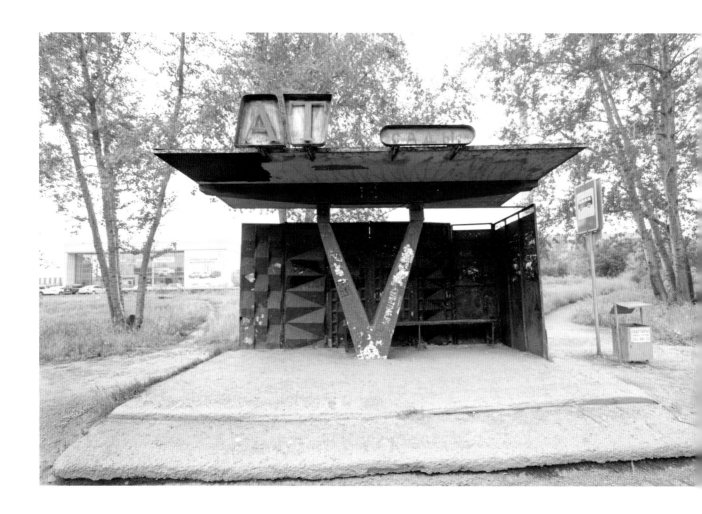

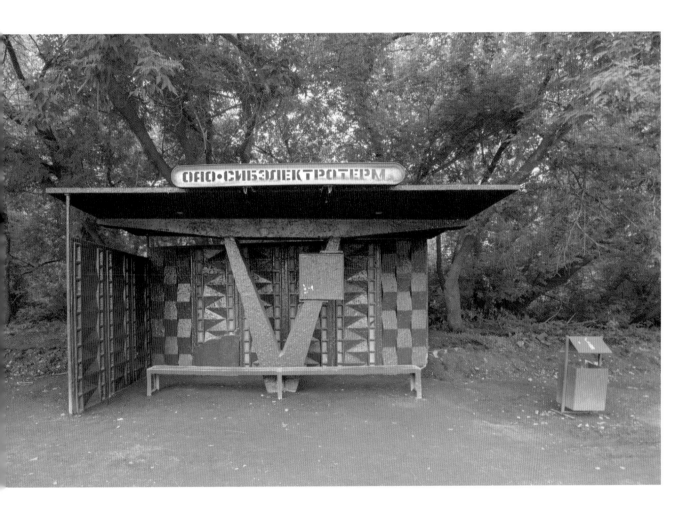

ОАО•СИБЭЛЕКТРОТЕРМ

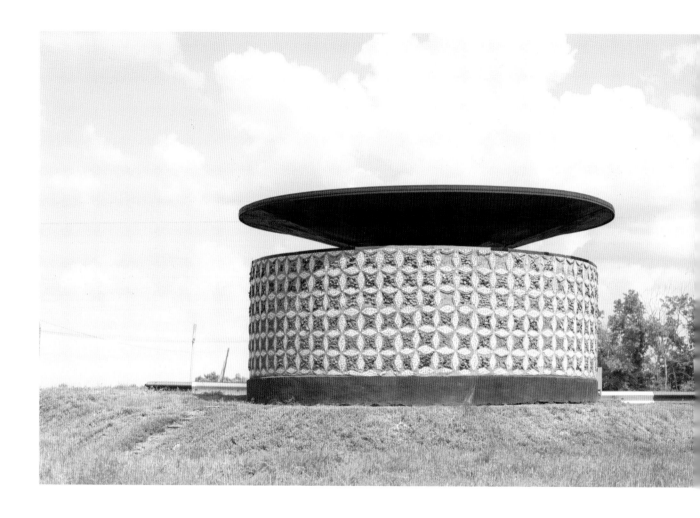

Kamenka, RUSSIA

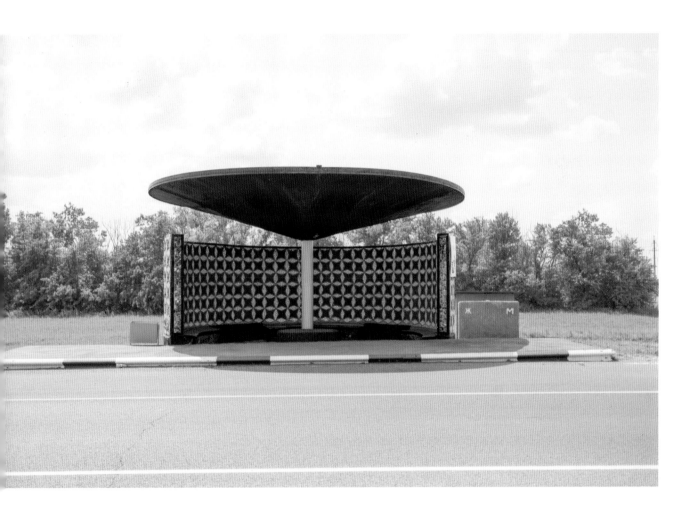

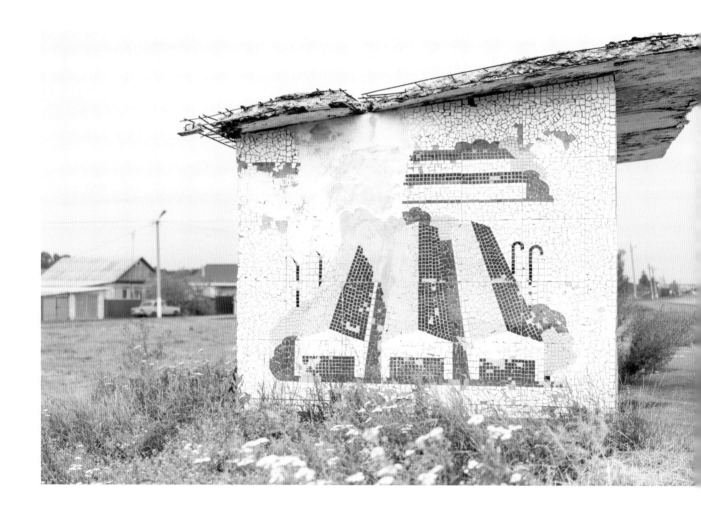

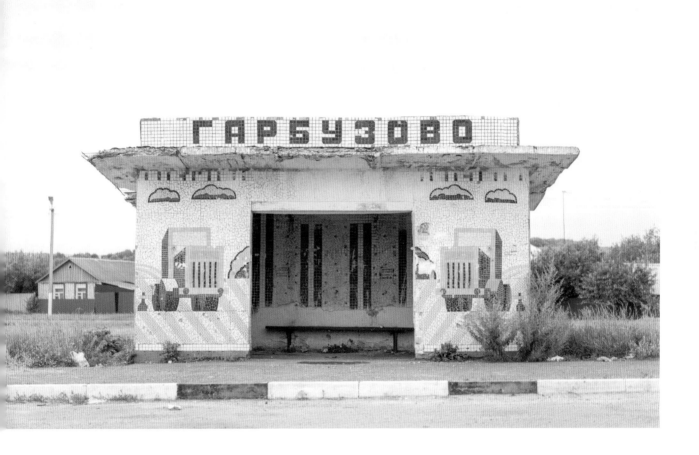

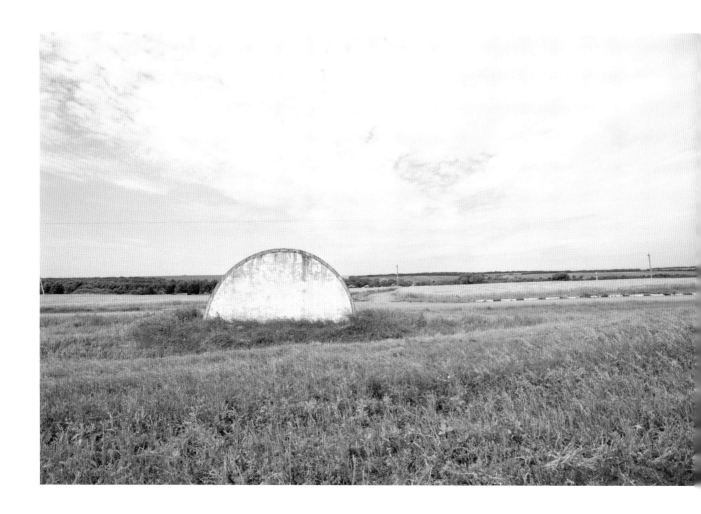

Belozorovo, RUSSIA

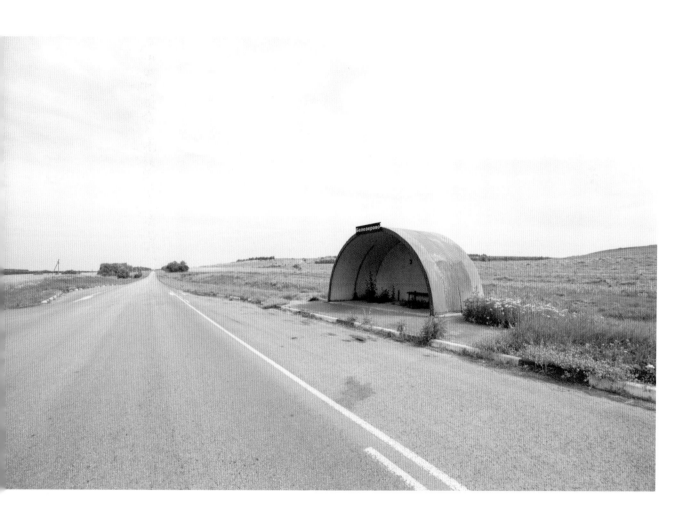

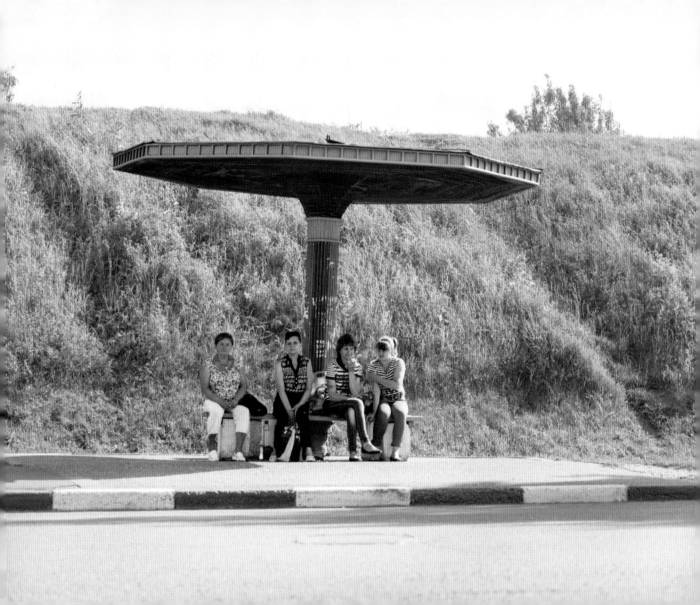

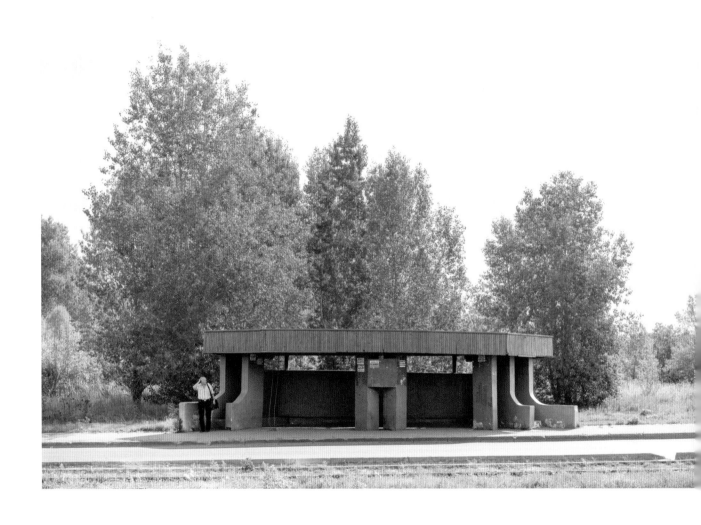

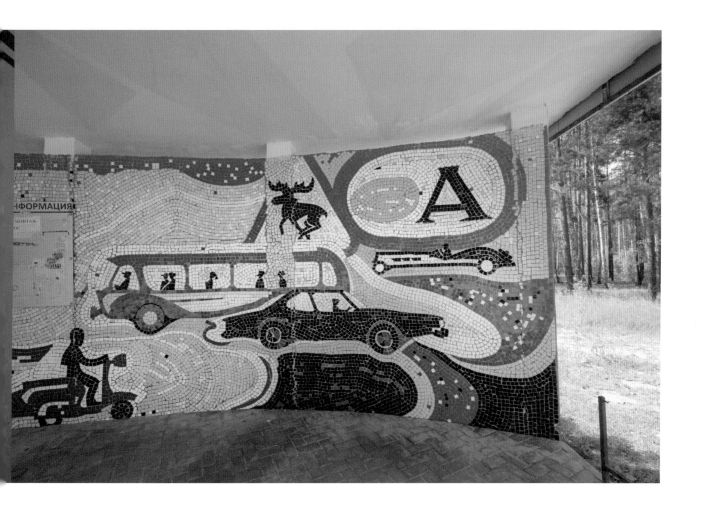

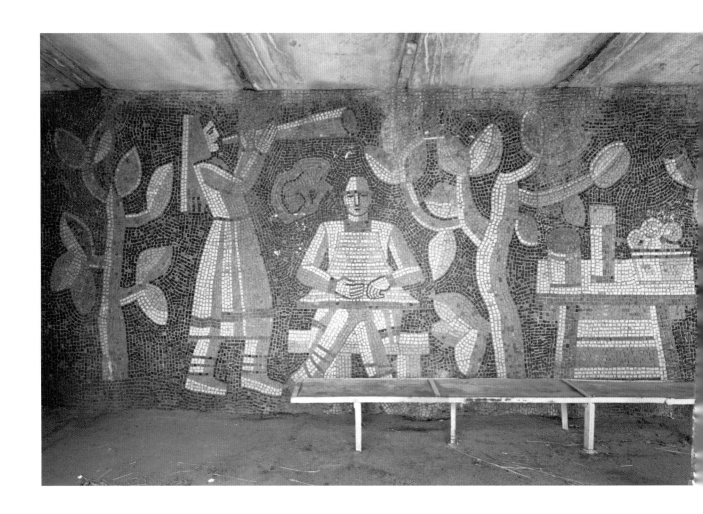

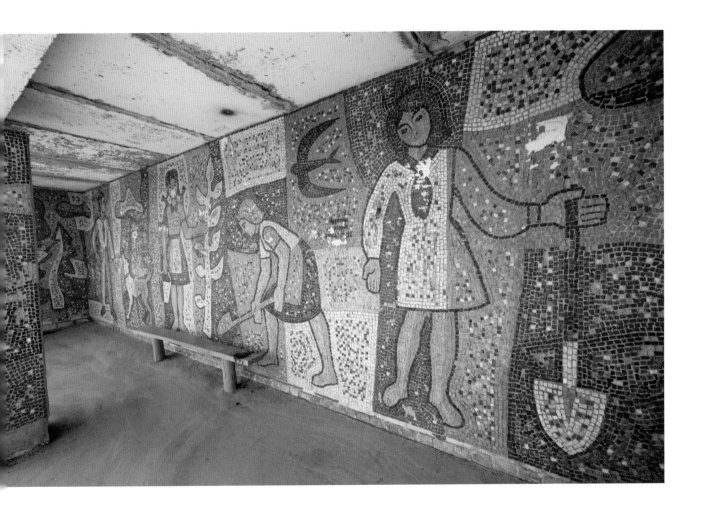

КУПЛЮ С КОТИКУ
8906-385-71-15

104 Madikasy, RUSSIA

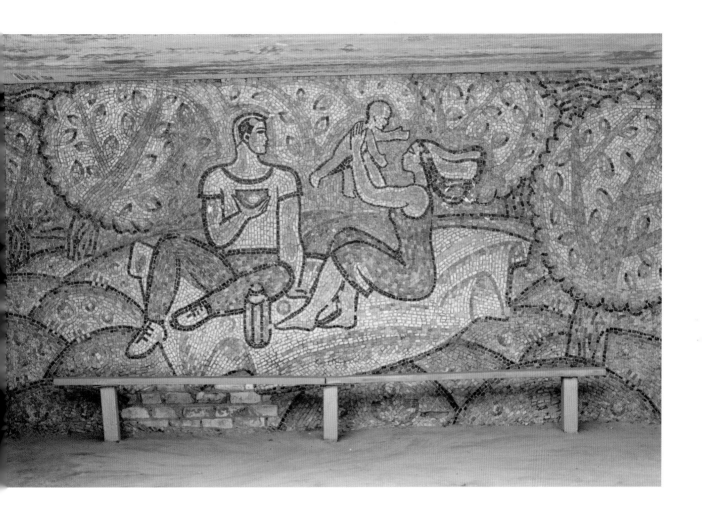

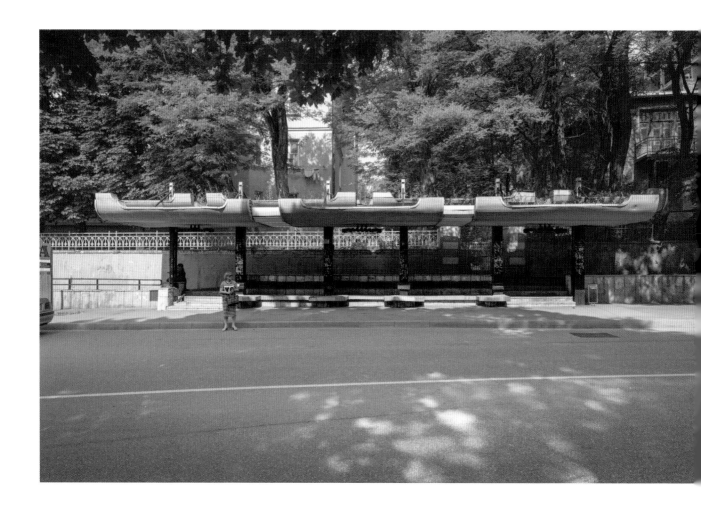

Kislovodsk, RUSSIA

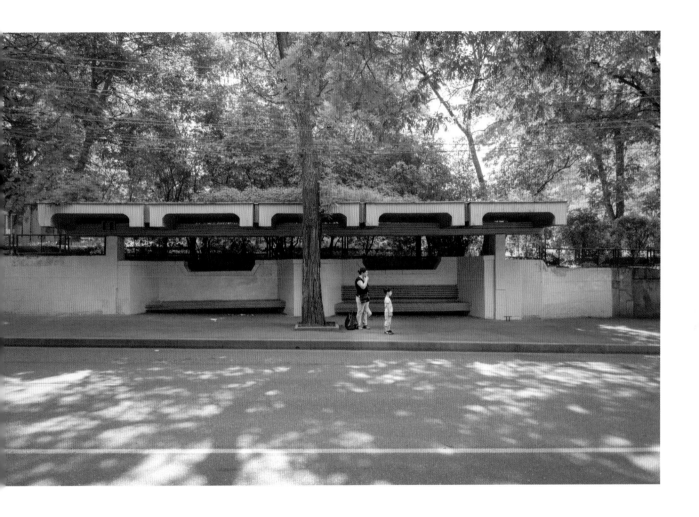

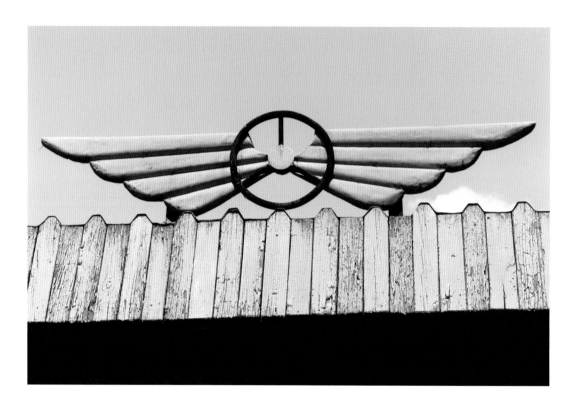

Stary Oskol, RUSSIA

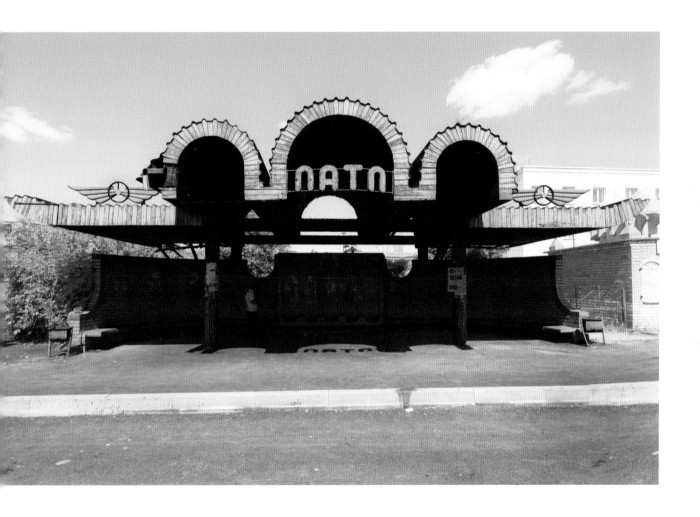

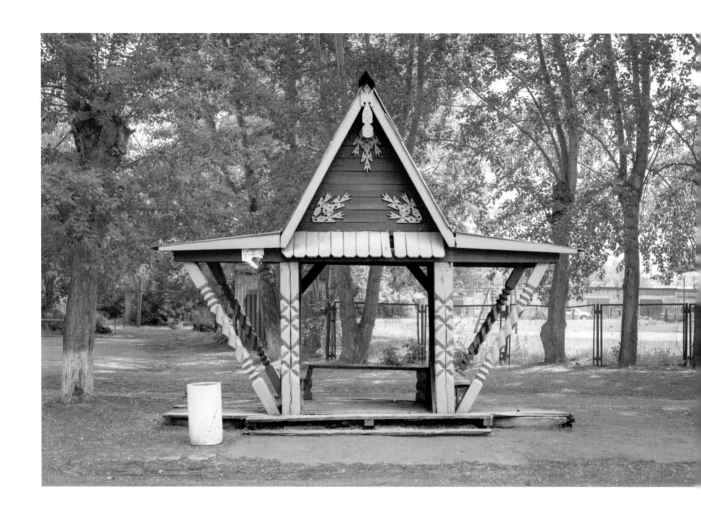

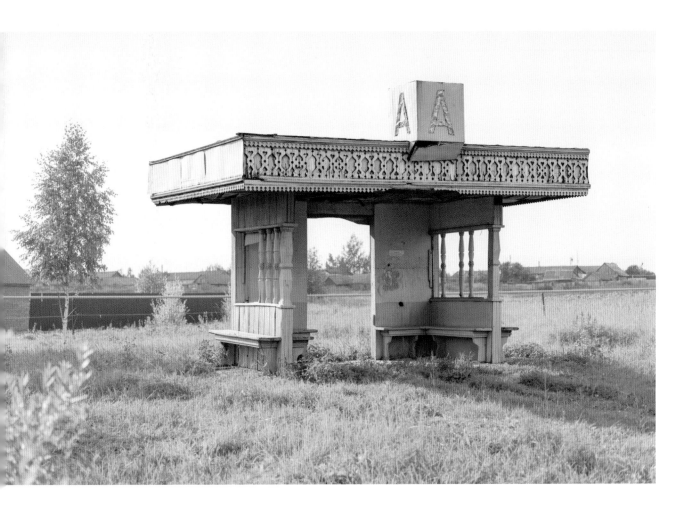

Balakovo, RUSSIA

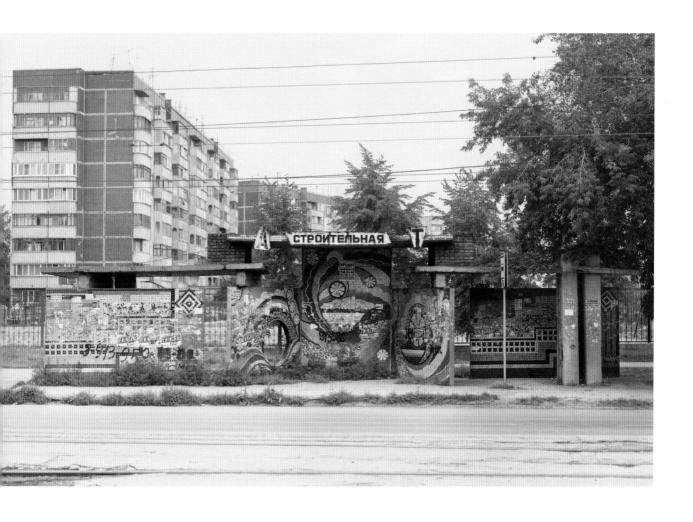

The sign on the structure reads: **СТРОИТЕЛЬНАЯ**

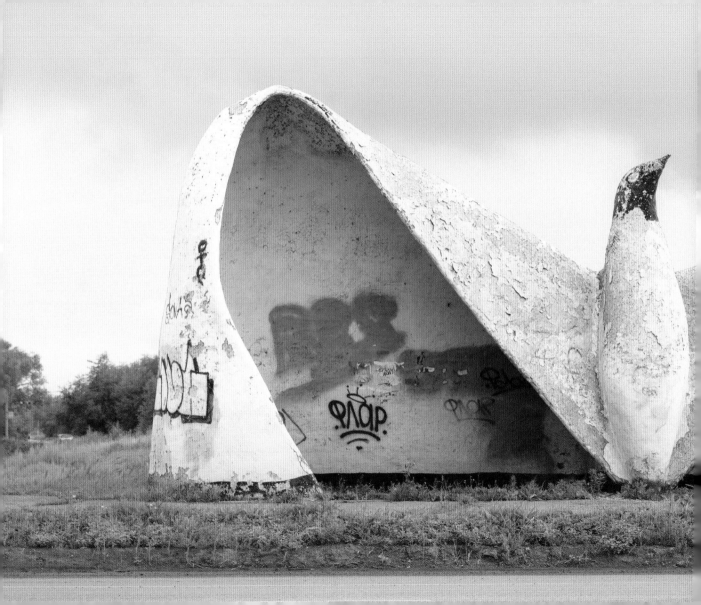

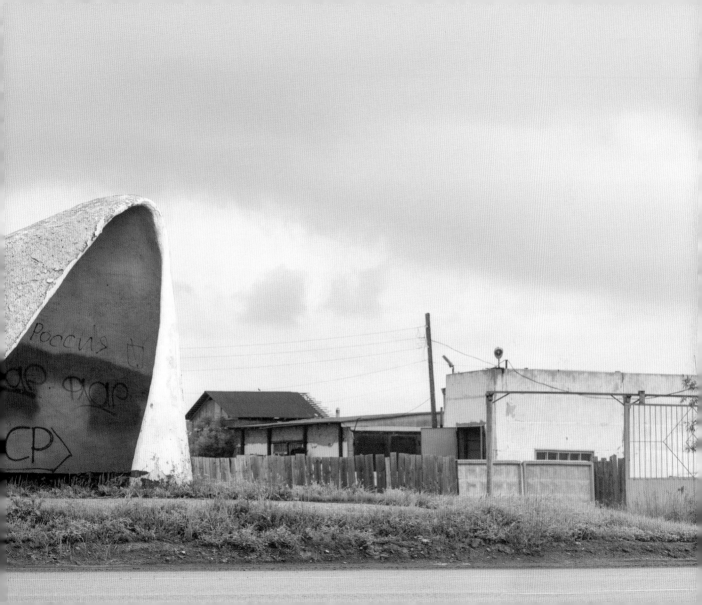

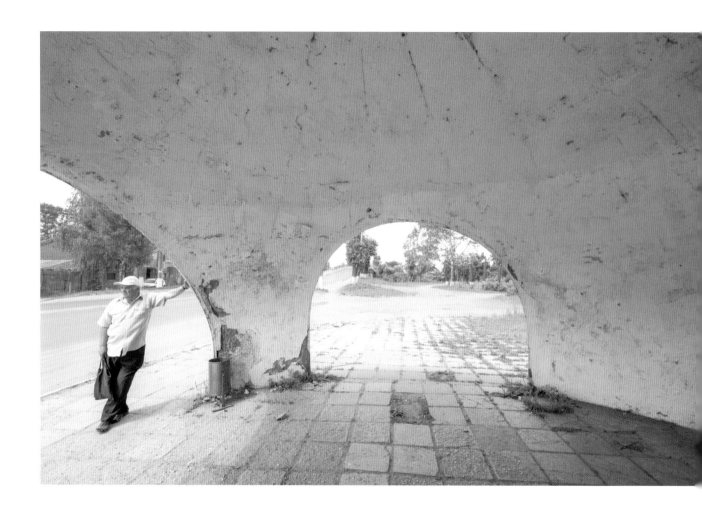

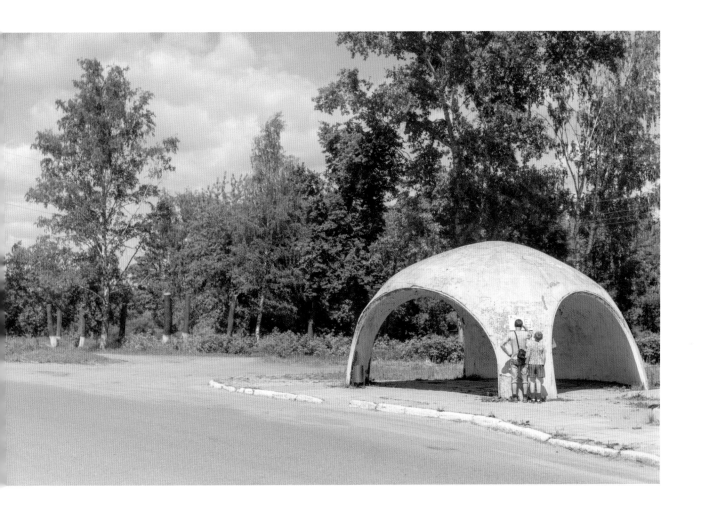

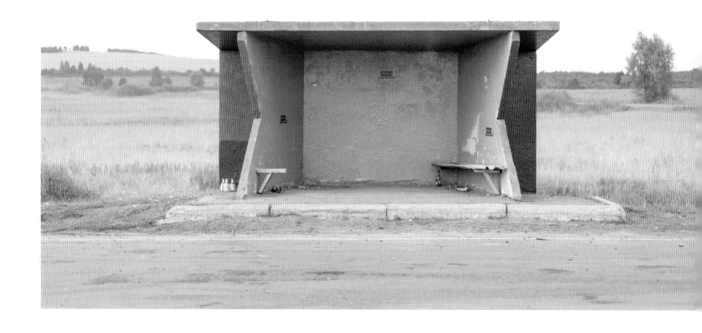

Shushnur, RUSSIA

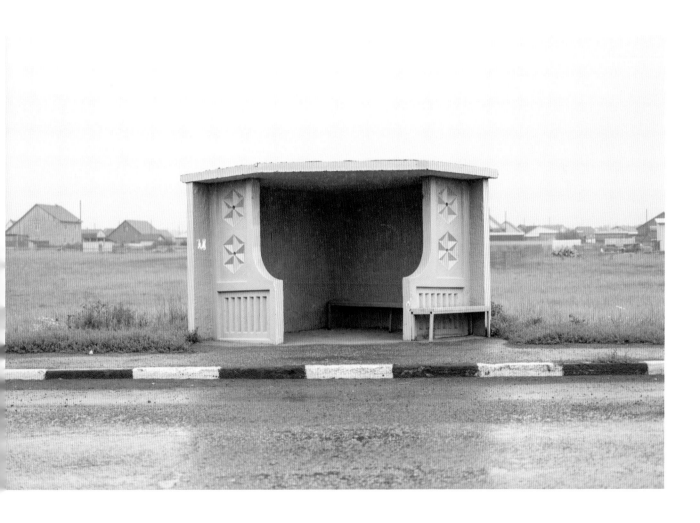

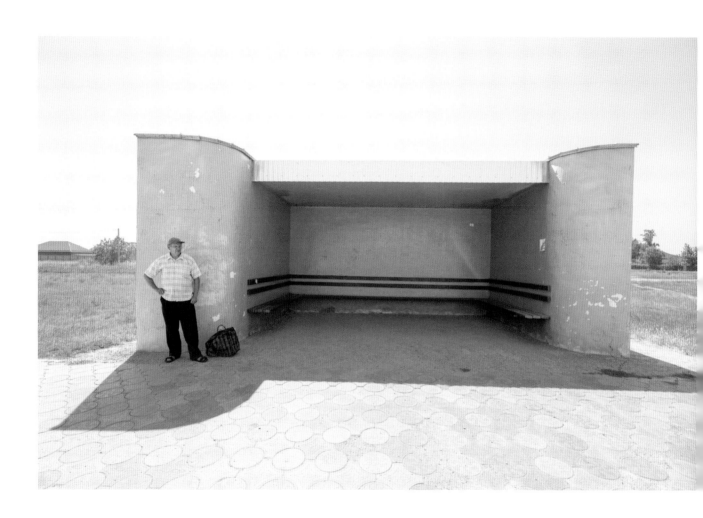

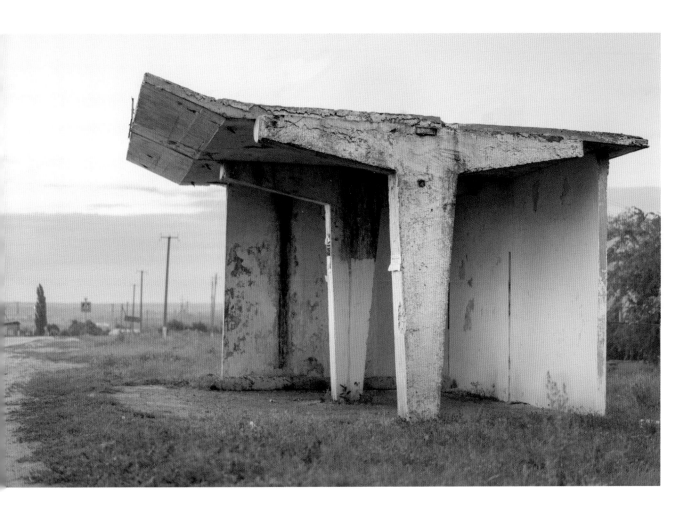

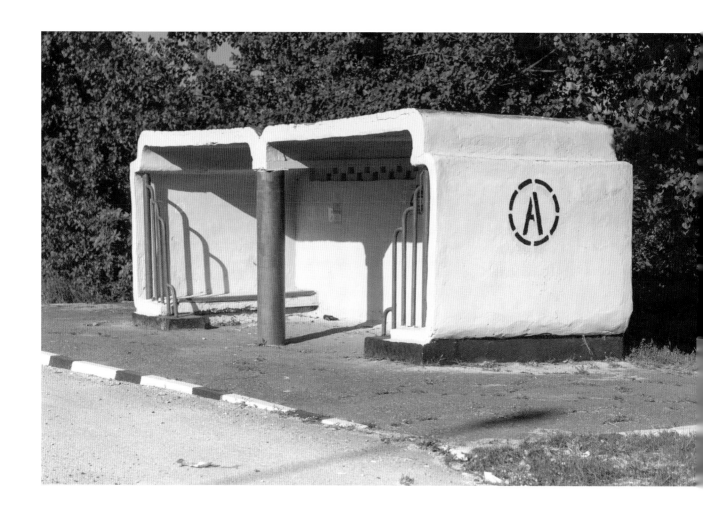

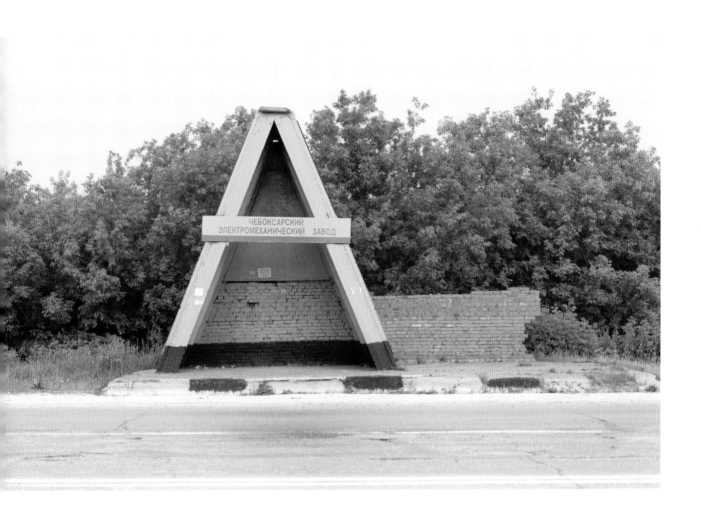

Electromechanical Factory, Cheboksarskiy, RUSSIA 125

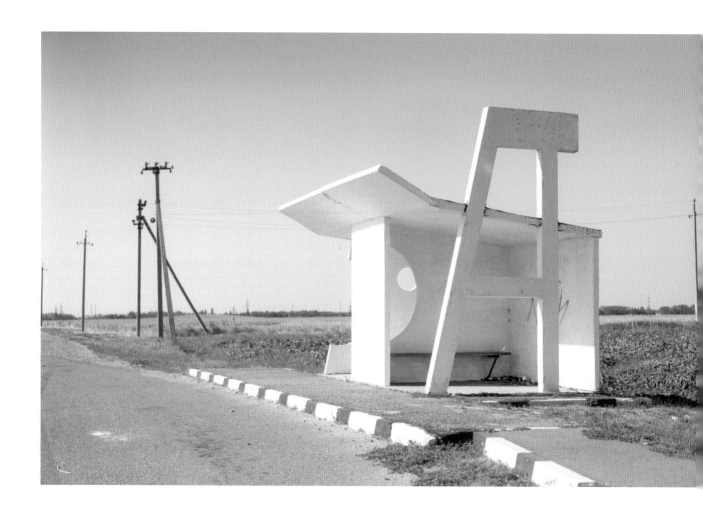

126 Dolinovskoye, RUSSIA

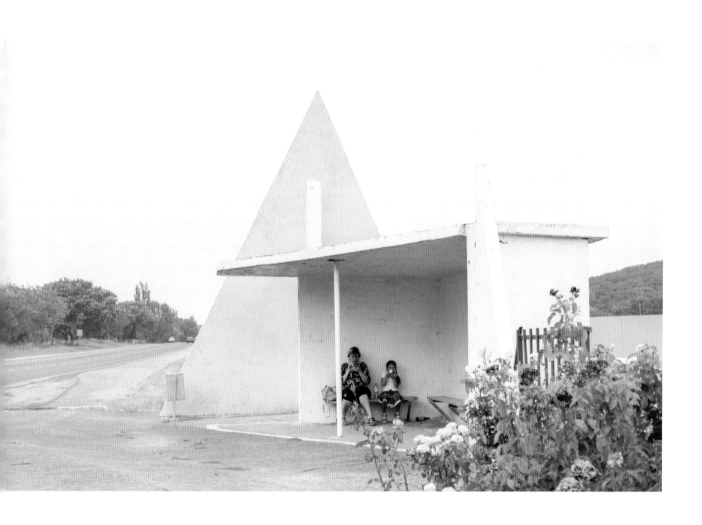

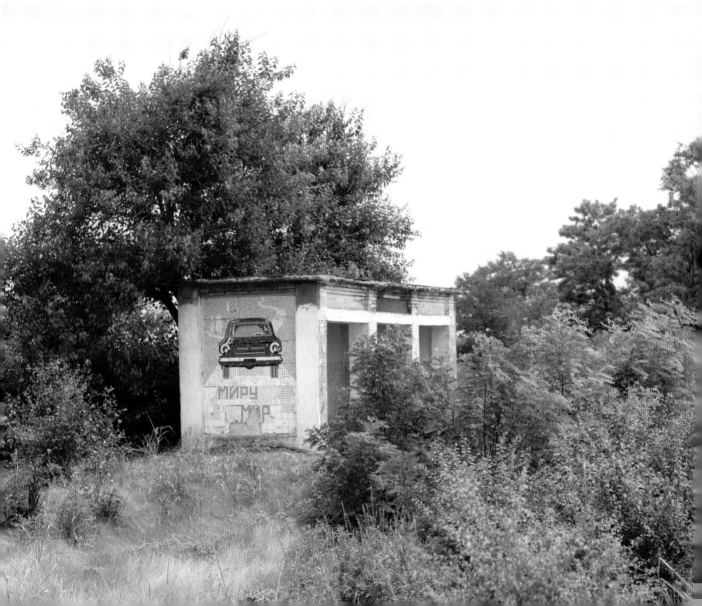

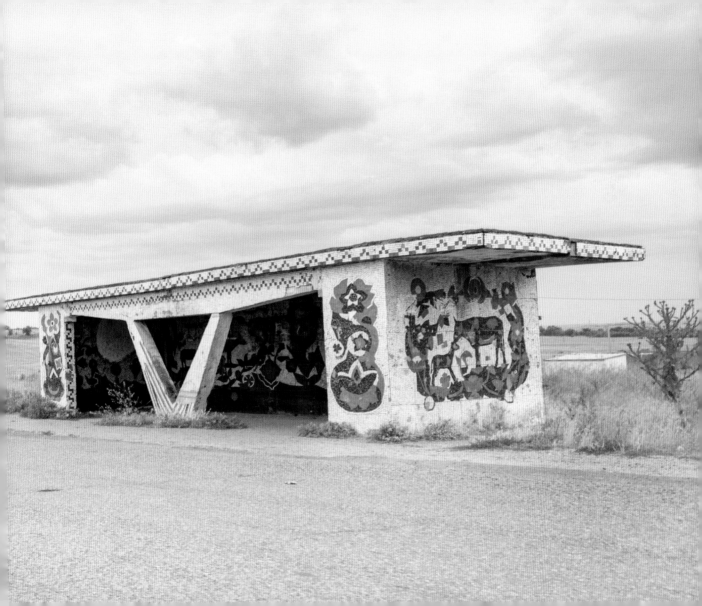

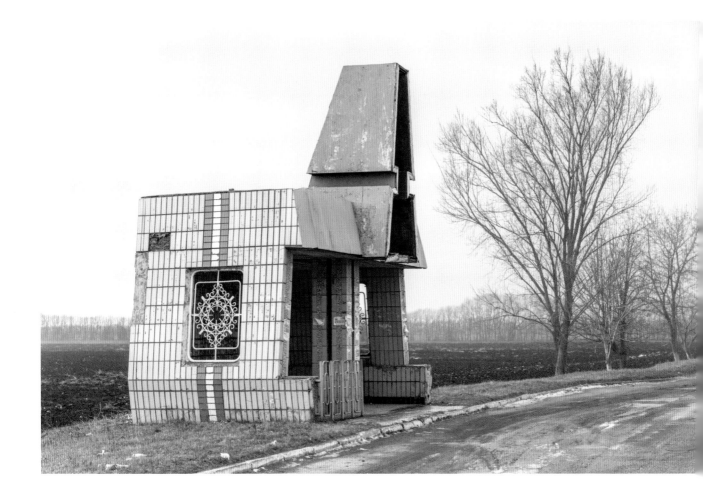

previous page: Lola, RUSSI

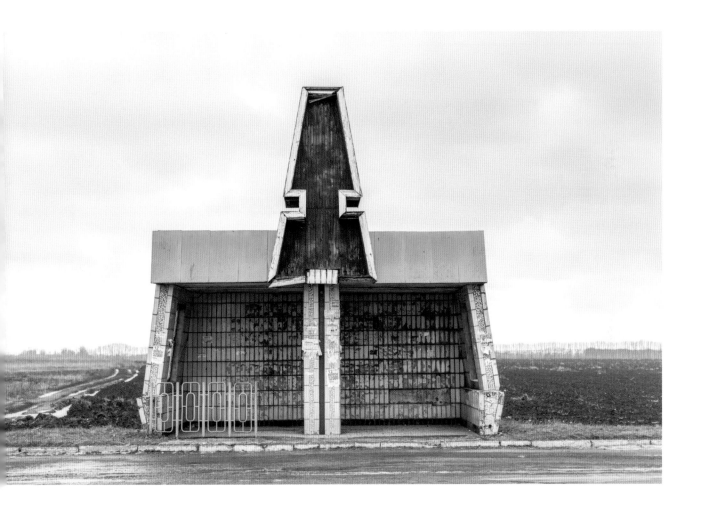

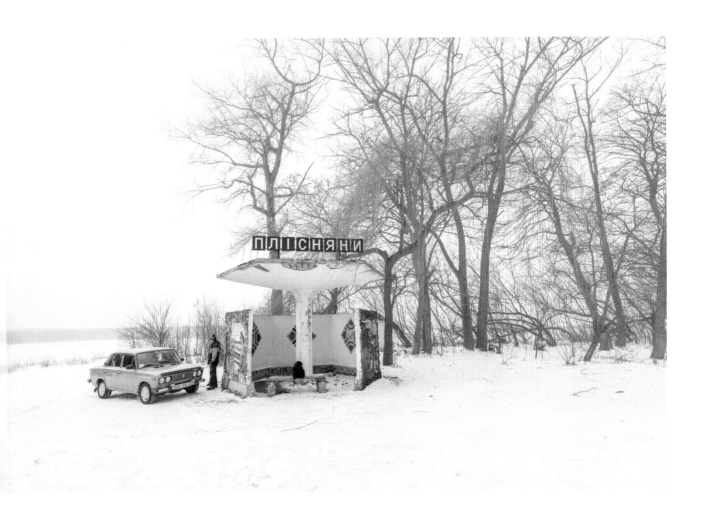

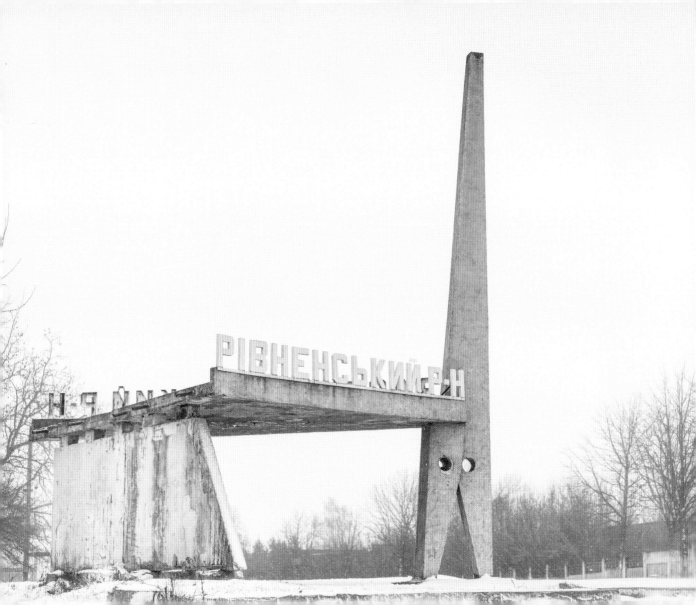

138 Leena, Mizoch, UKRAINE

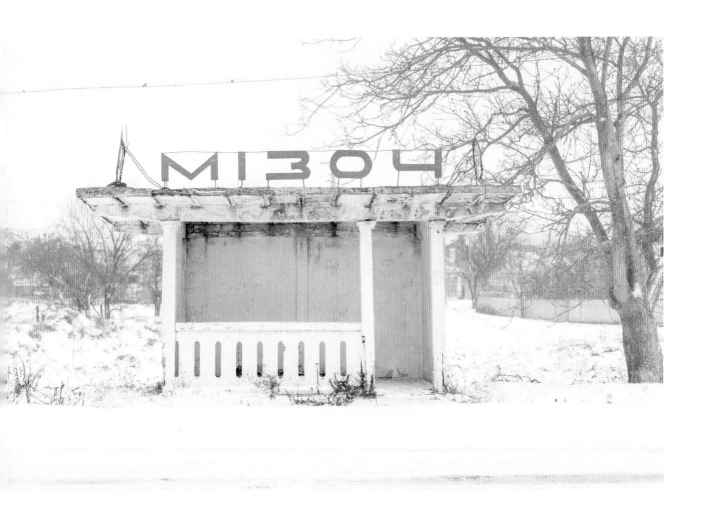

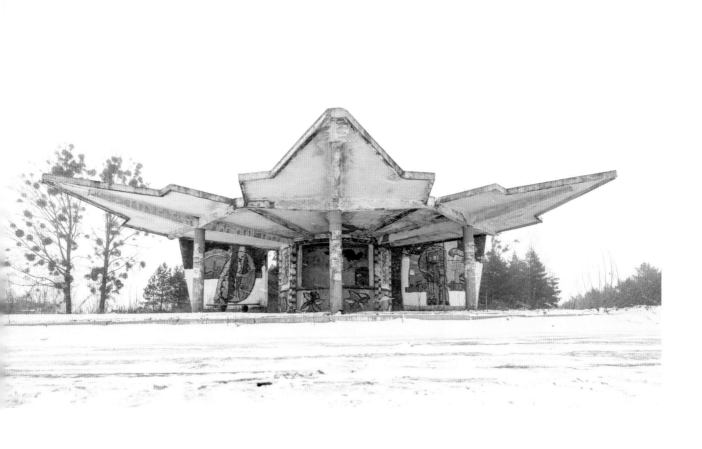

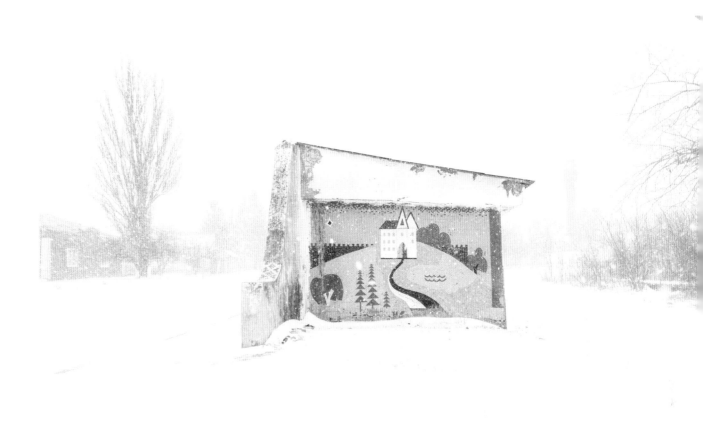

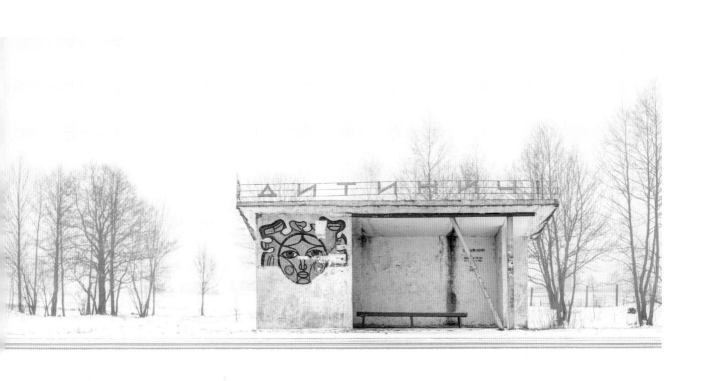

Dytynychi, UKRAINE 143

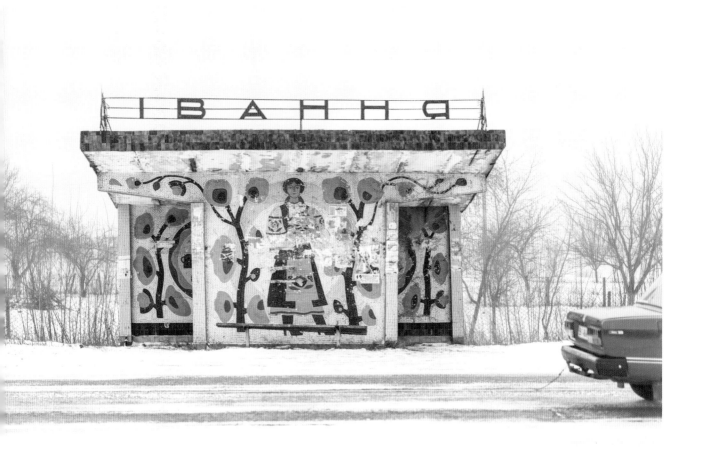

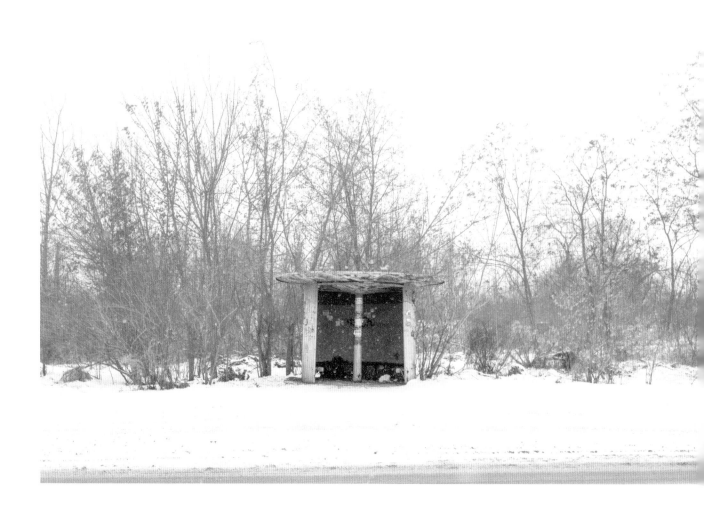

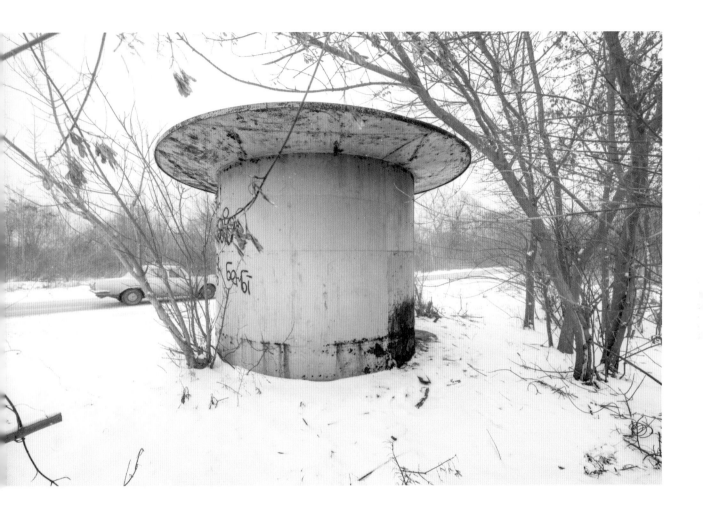

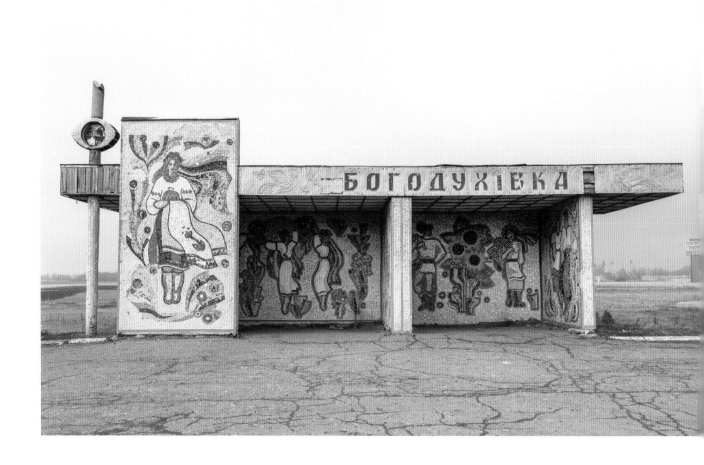

148 Bohodukhivka, UKRAINE

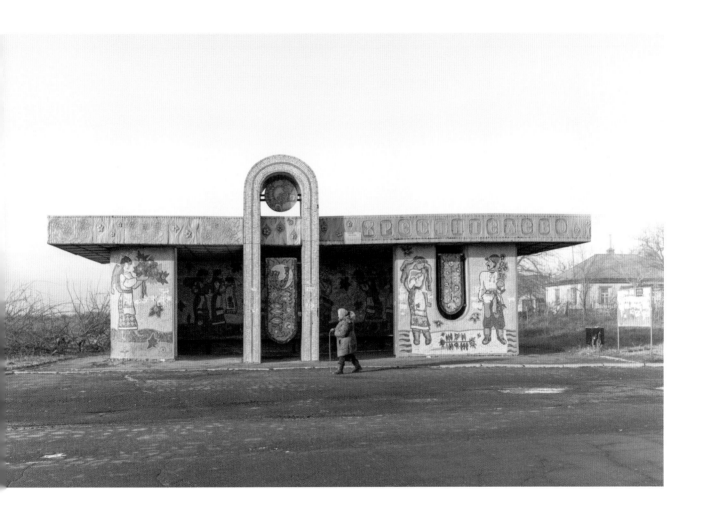

150 Victor Lazarenkoi, bus stop architect, Kiev, UKRAINE

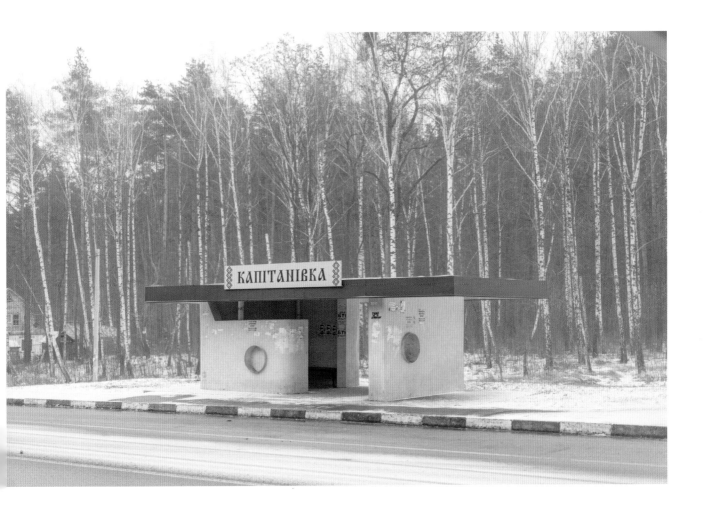

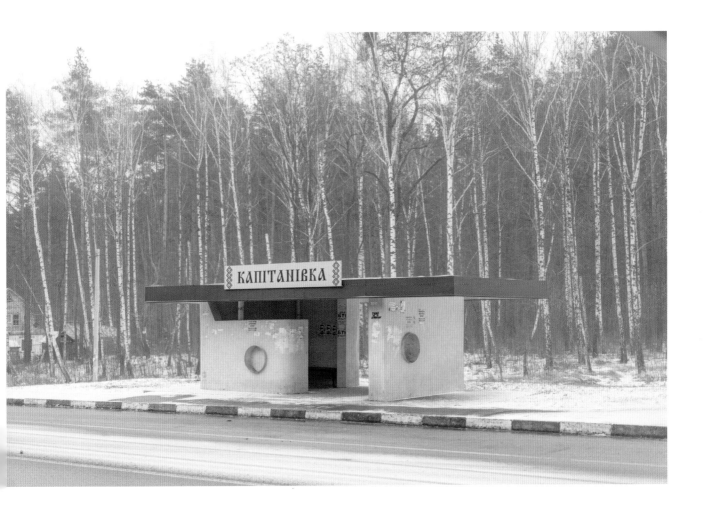КАПІТАНІВКА

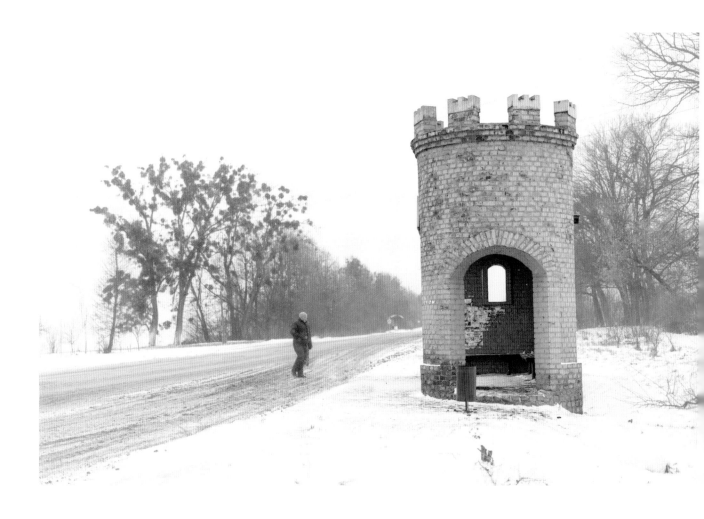

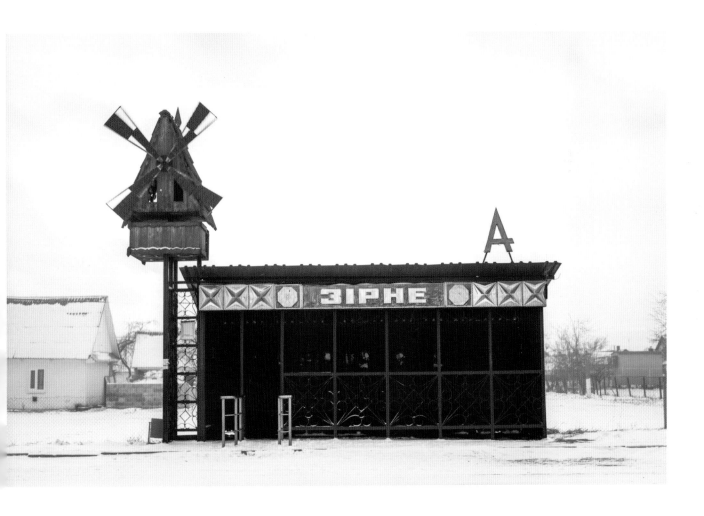

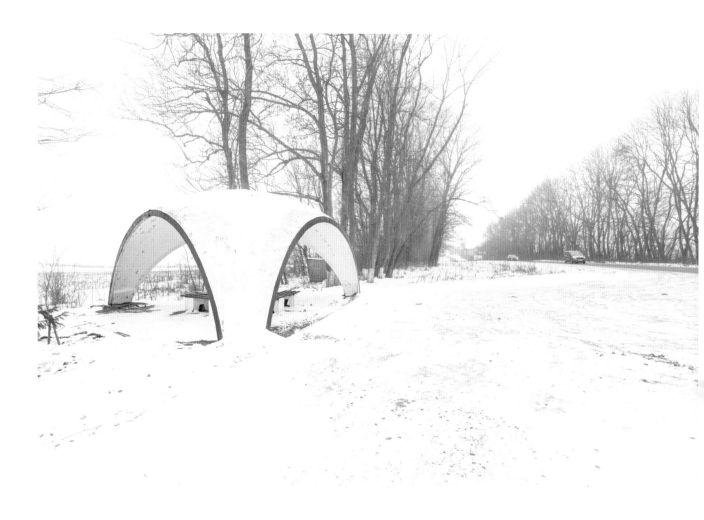

Plisnyany, UKRAINE

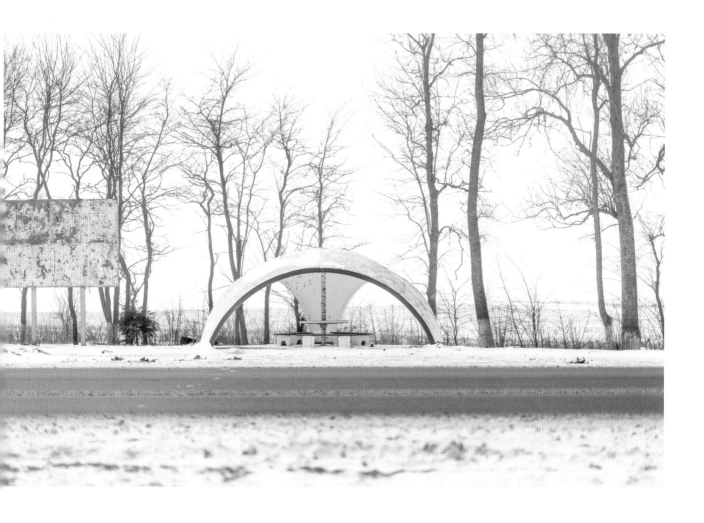

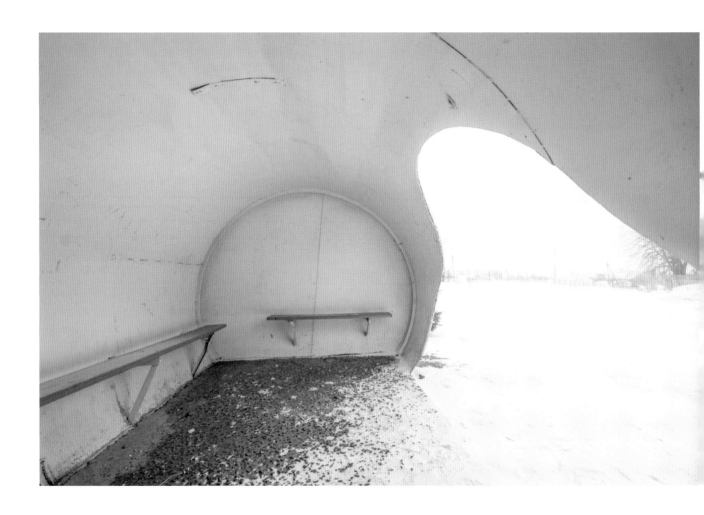

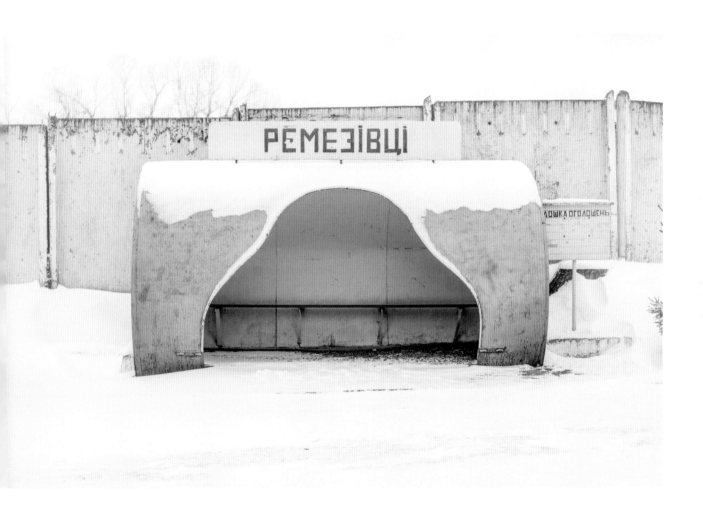

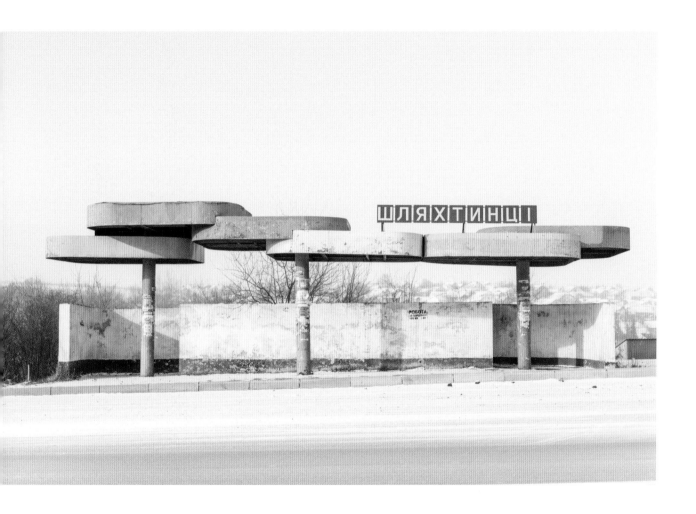

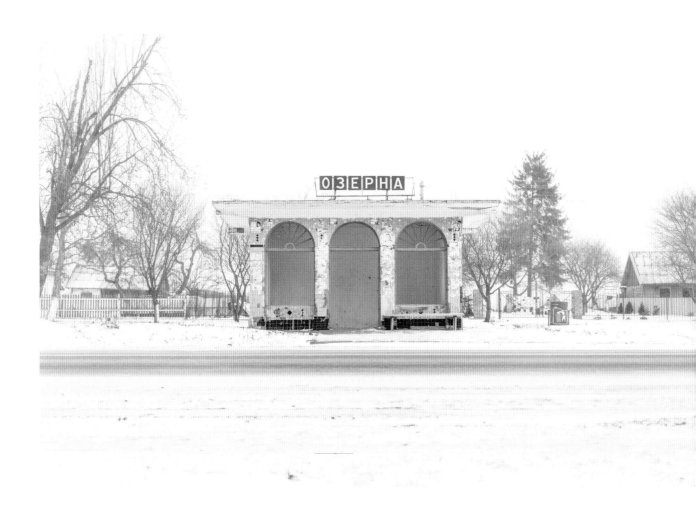

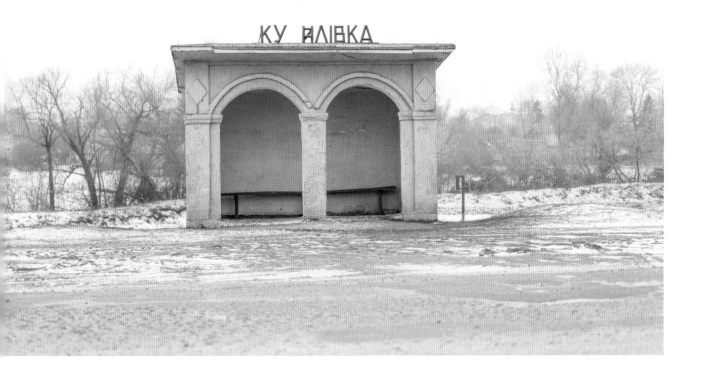

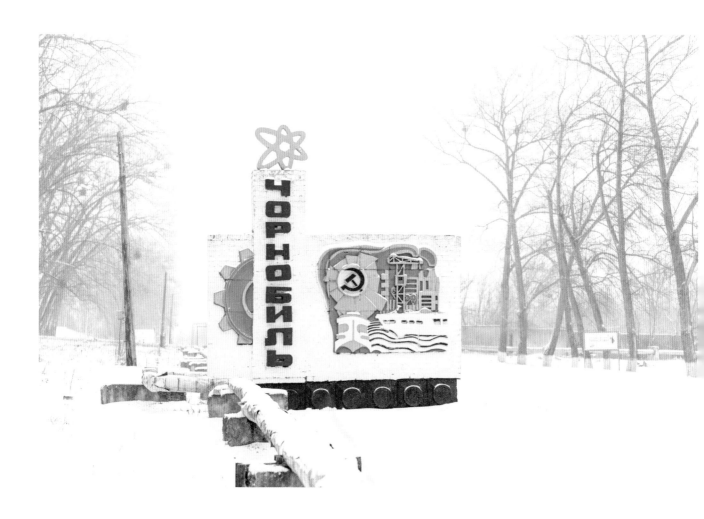

164 Chernobyl, UKRAINE

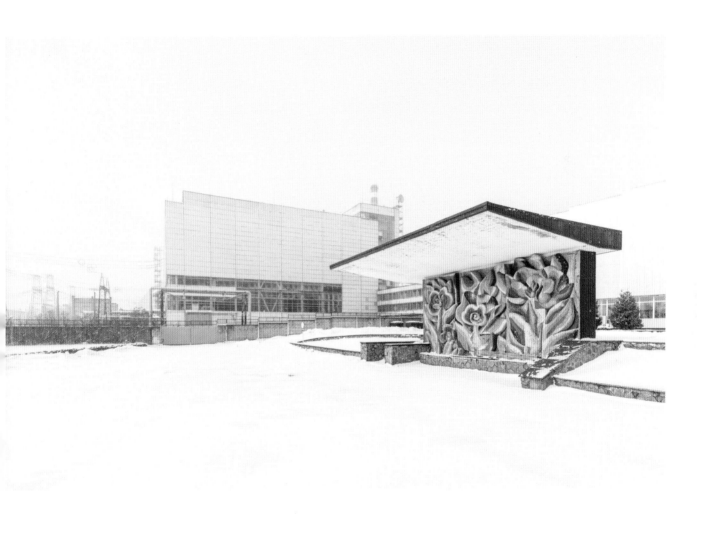

МИНИСТЕРСТВО АВТОМОБИЛЬНОГО ТРАНСПОРТА УССР
КИЕВСКОЕ ОБЛАСТНОЕ УПРАВЛЕНИЕ ПАССАЖИРСКОГО
АВТОТРАНСПОРТА
КИЕВСКОЕ ОБЛАСТНОЕ ОБЪЕДИНЕНИЕ АВТОБУСНЫХ
СТАНЦИЙ ЭКОЭЭ

АВТОБУСНАЯ
СТАНЦИЯ
"ПРИПЯТЬ"

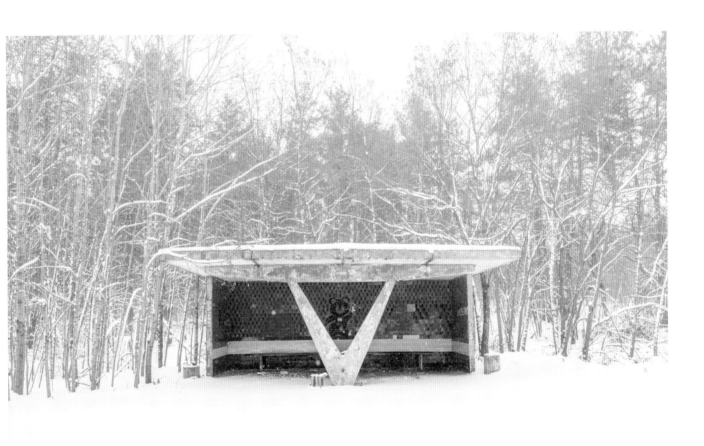

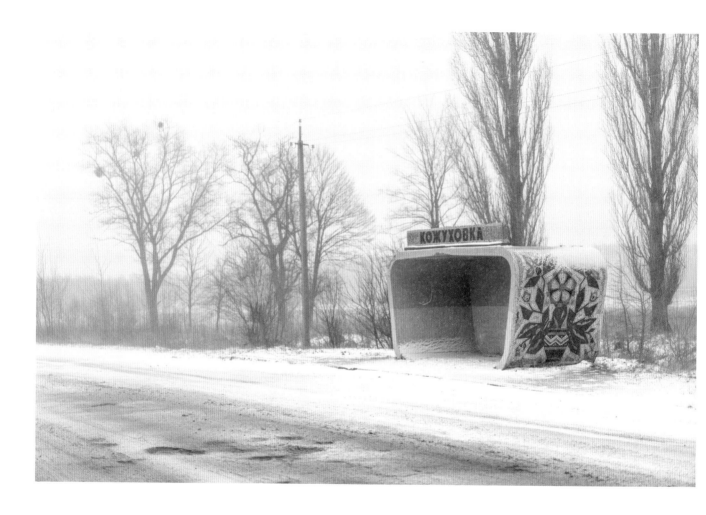

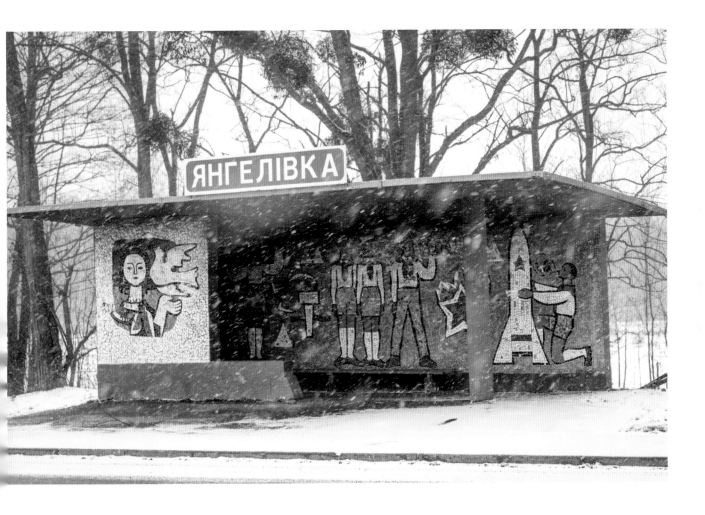

ЯНГЕЛІВКА

Yanhelivka, UKRAINE 169

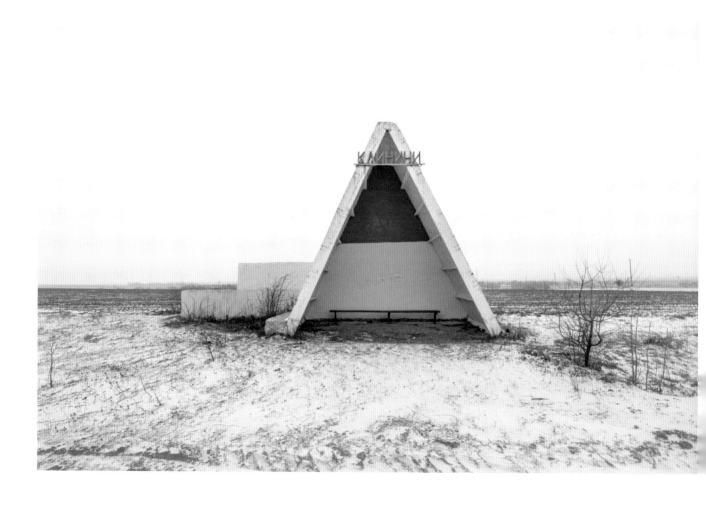

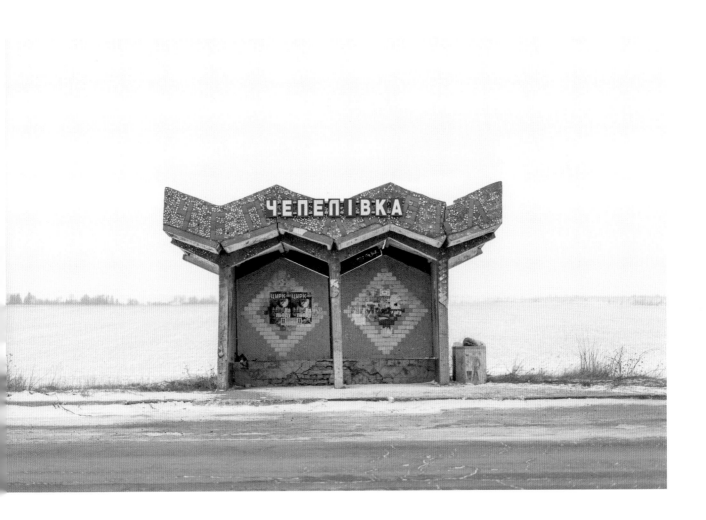

ЧЕПЕЛІВКА

Chepelivka, UKRAINE 171

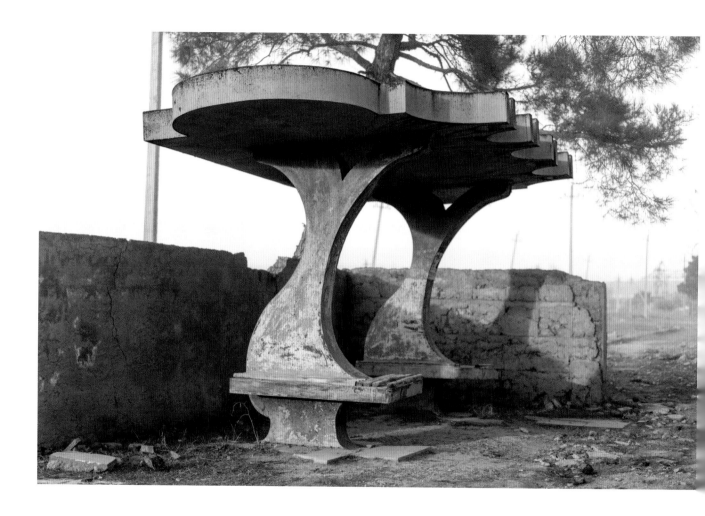

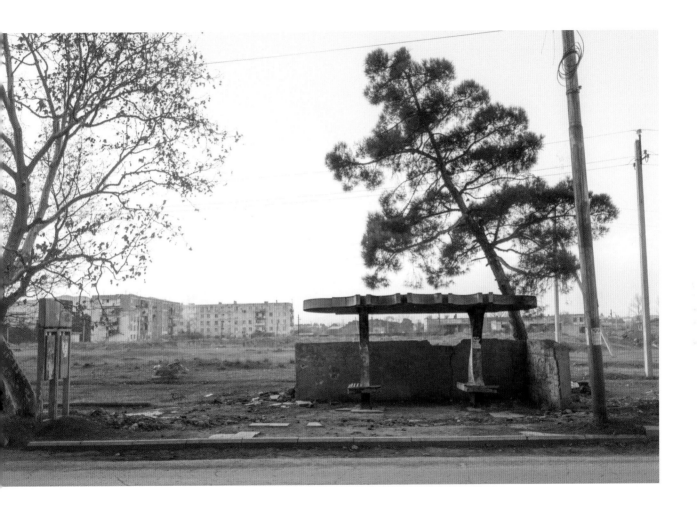

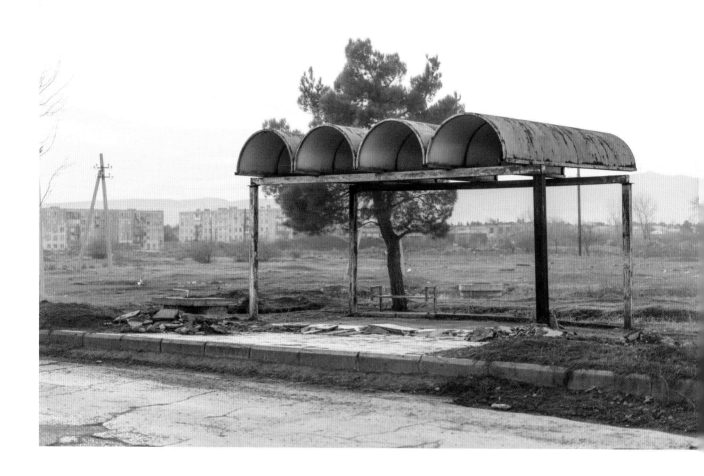

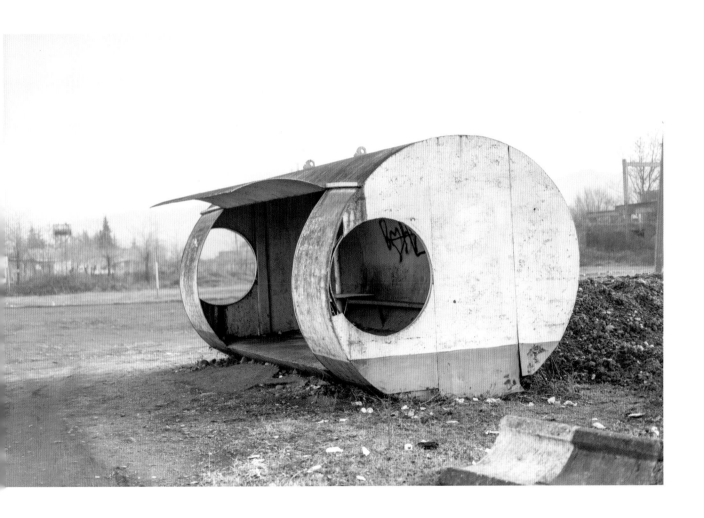

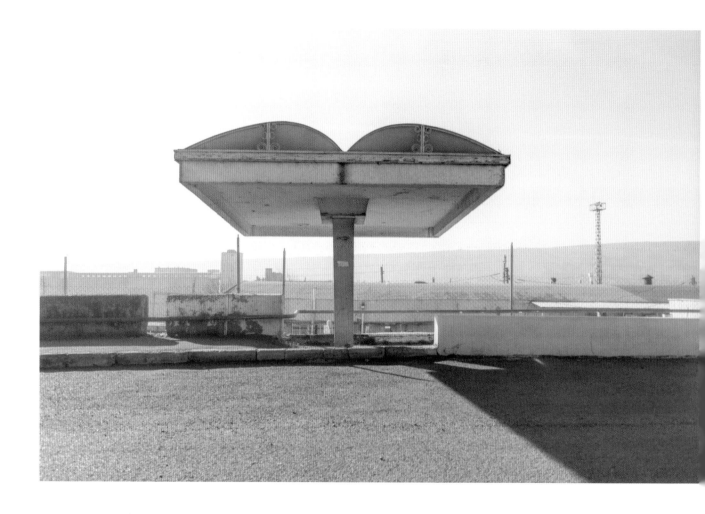

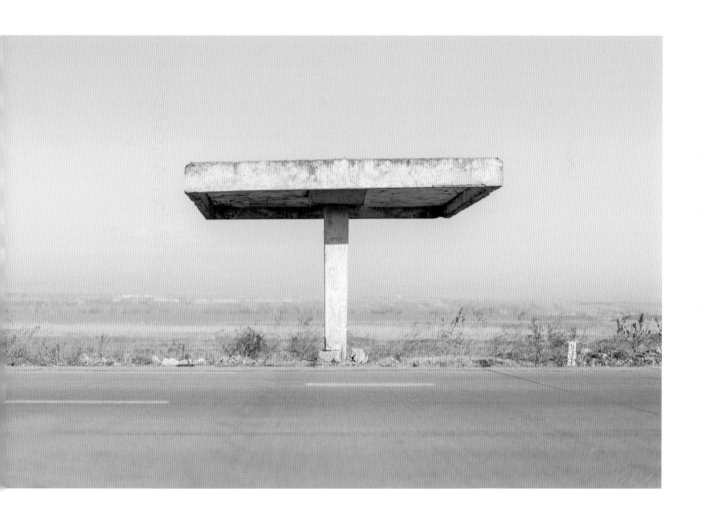

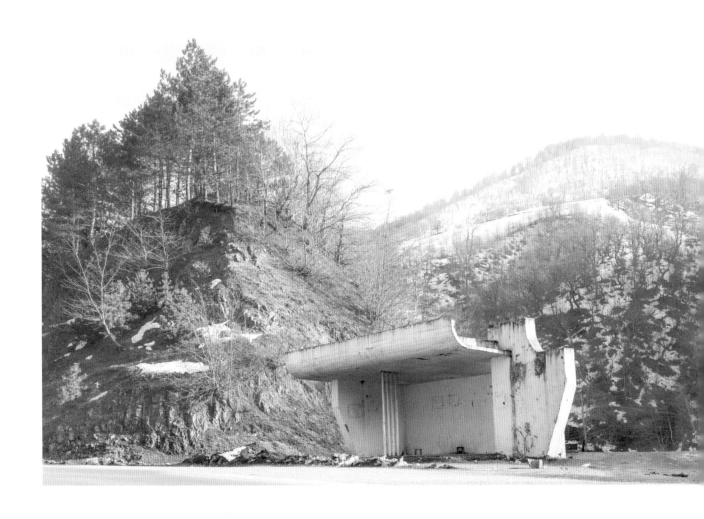

178 Tsakva, GEORGIA

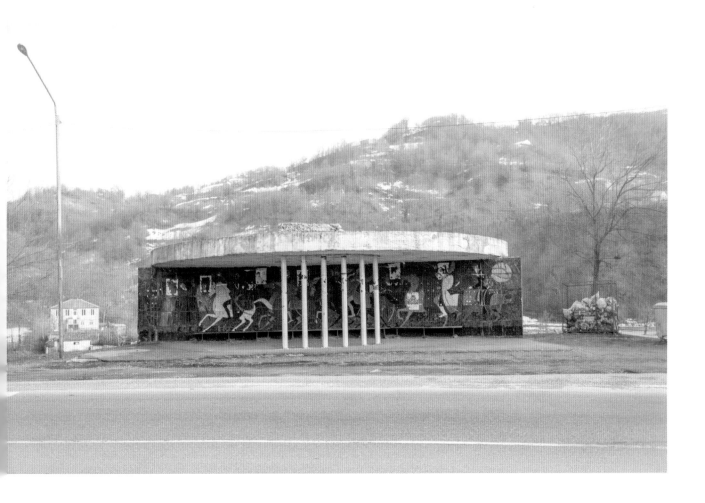

Igoeti, GEORGIA

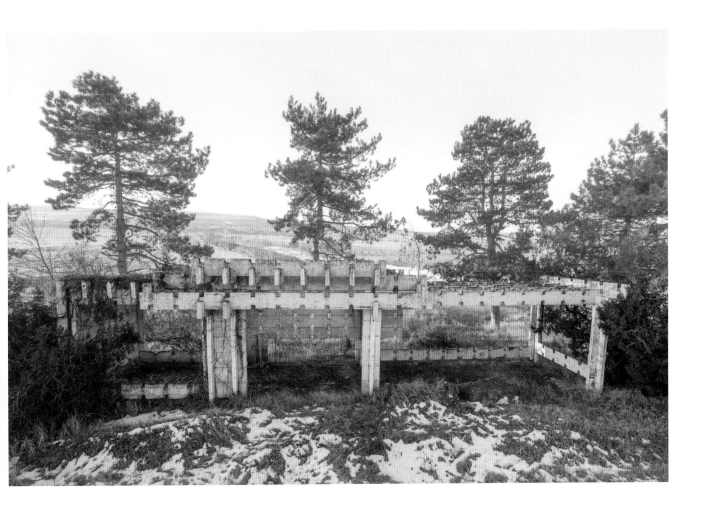

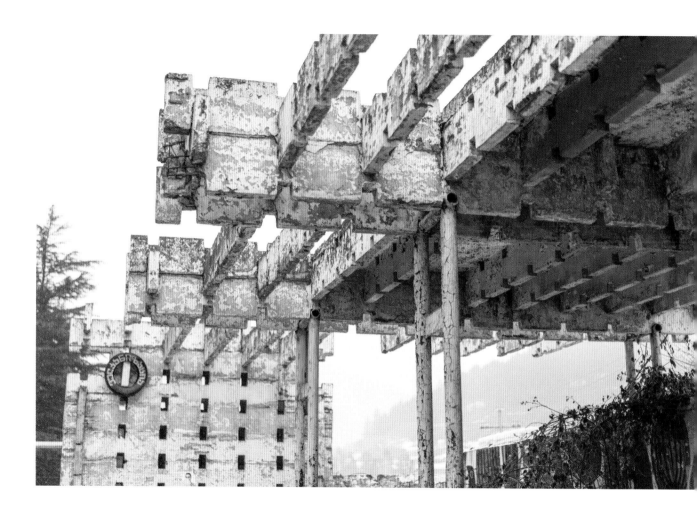

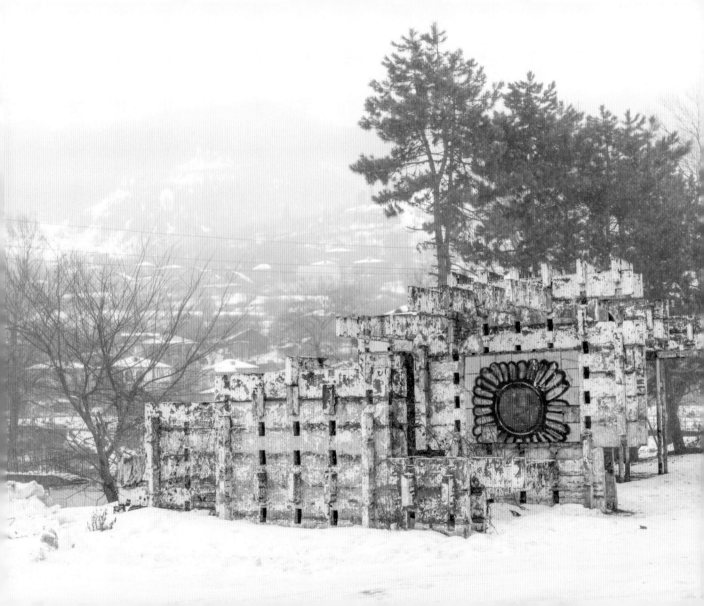

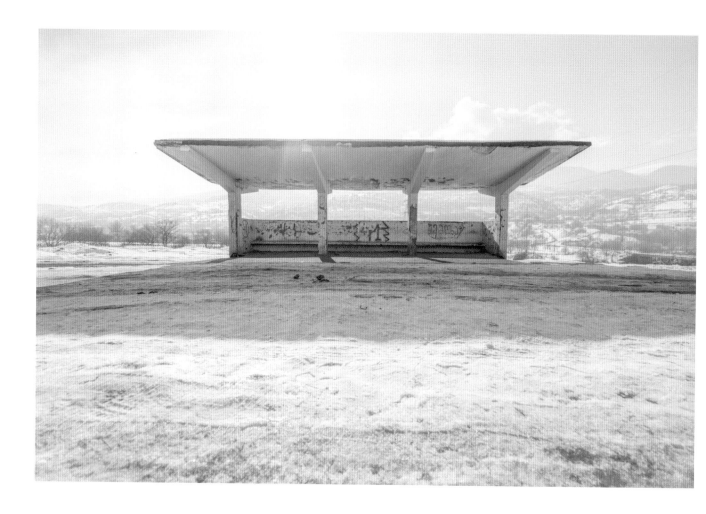

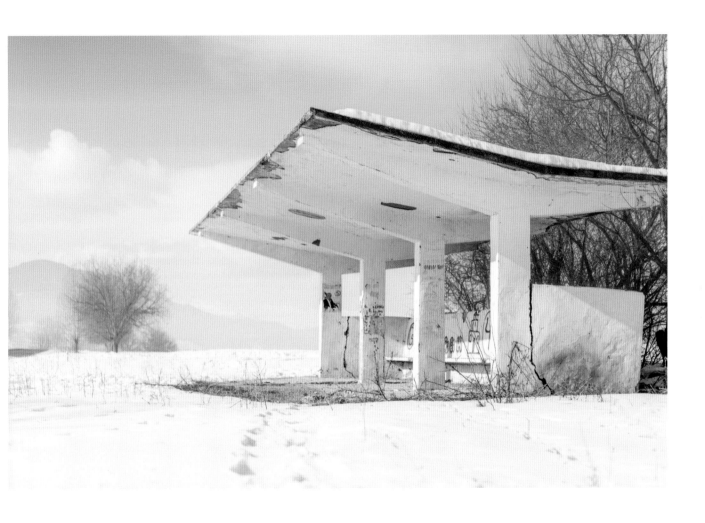

Akhaltsikhe, GEORGIA 185

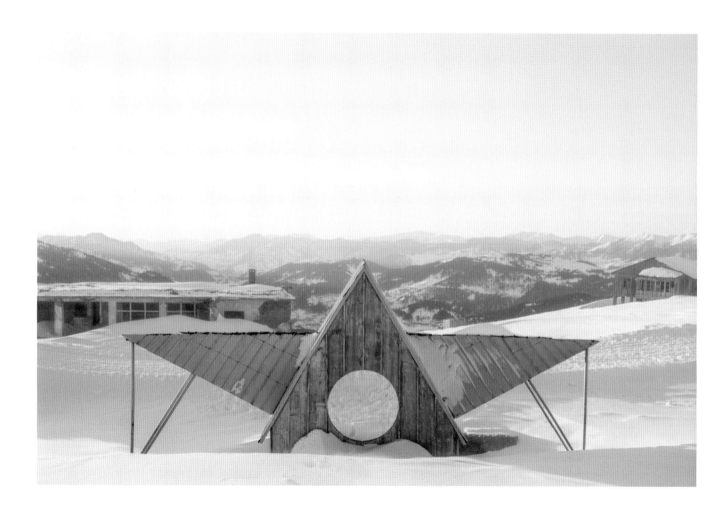

Goderdzi Pass, GEORGIA

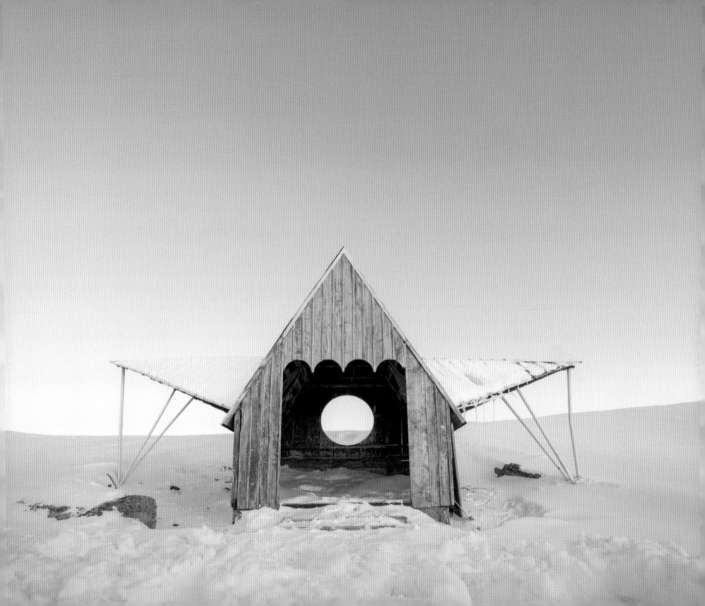

Afterword
Christopher Herwig

GEORGIA, JANUARY 2017. 'This is bullshit,' I mumbled, through tears of exhaustion and frustration. The chances of the 4x4 climbing the snowy Goderdzi Pass were as slim as the likelihood that the bus stop at the summit was the prize I so desperately sought. Why was I still doing this after fifteen years, why couldn't I stop?

SEPTEMBER 2015. After thirteen years of work, *Soviet Bus Stops* is published. My dream of seeing these far-flung architectural oddities together in print is finally realised. The attention the publication receives across the world exceeds all my expectations. For the fifth time, I declare I'm finished with the project. Just days later, I find myself searching online for images of Russian bus stops. The country was an obvious omission from the first book. I made that decision because I felt that a parallel existed between the bus stops as underdogs of architecture, and the former Soviet republics that were often overshadowed by Russia. However, as the book gained recognition, so Russian blogs and groups emerged celebrating their bus stops. These people had always appreciated them, but the book stimulated more open discussion. Fellow hunters would share locations, information

and tips; through the darkness a route was taking shape. For months I spent late nights trawling the Internet, making new friends and driving roads in Google street view.

An expert on Soviet architecture in Moscow rejected the architectural significance of the bus stops, informing me that they were the inferior works of amateurs. This prevailing elitist attitude is clearly demonstrated by the absence of any conservation programme. Understanding how they were under-valued and underappreciated only made me love them more. If I didn't continue, somehow I would be betraying these forgotten gems. I felt charged with a duty to preserve them, if only in my photographs.

RUSSIA, JULY 2016. Armed with a 30-day Russian visa, I knew the clock was ticking. I had my research, but I wanted more – I felt like a detective, an explorer, a spy on an adventure. The urgency of my mission was confirmed on the first day: most of the bus stops visible on Google street view had already been destroyed. My coordinates weren't always precise, but would often serve as a starting point from which I could sniff out other stops. But I wasn't aiming for

quantity, or even some preconceived form of beauty – as my hard drive filled with nearly 10,000 new images, I was consumed by the certainty that the next bus stop would be more extraordinary than the last. I felt compelled to record these improbable creations that, despite circumstances and lack of materials, had achieved architectural singularity. The planned 10,000 kilometres extended to 15,000. The majority of main roads had been relaid and their bus stops replaced: the paths less travelled were where my quarry lay.

A combination of double espressos and a Russian energy drink called 'G-drive' fuelled the search, allowing me to continue from dawn to dusk. I would jump out of the car and sprint around each bus stop, dancing to find angles and perspectives, a performance choreographed to produce the most favourable composition between the shape of the stop and its surroundings. But the caffeine also fed my anxiety. Time was running out – should I stop for this one? If I do, I run the risk of missing an as yet undiscovered hero further on. The longer the wait, the greater the joy, as the dot on the horizon revealed itself to be bus stop glory.

At night, a few measured shots of vodka would slow me down enough to drift off to sleep. But my dreams were filled with the never-ending road, and bus stops that could only exist in my imagination – fantastic out-of-this-world shapes that I longed to find. As I approached Vladivostok, at the end of my journey, the bus stops became fewer and less impressive. Though happy in the knowledge that I'd exceeded my expectations, I couldn't dispel the nagging feeling that I'd not yet reached my destination.

UKRAINE AND GEORGIA, JANUARY 2017. I stared at my GPS and compared it to my phone: both screens were empty, confirming that the car was some distance from any known road. In the excitement of the hunt I had become completely lost in the Ukrainian countryside, driving along unpaved or cobbled stone streets, through villages whose most impressive structures were their bus stops. It was not the first time this had happened. It was then that I realised why I felt unfulfilled after completing the longest road trip of my life. I recognised that the project wasn't going to end at a specific destination. Of course – salvation could only come in the form of a bus stop.

And so the hunt continued. With the cold and snow snatching my breath away, I found satisfaction outside old factories and infamous nuclear power plants. Ultimately, one bus stop remained for me, at the summit of a 2000-metre Georgian pass, along a road considered one of the world's most dangerous. As my heavy Land Cruiser sunk into the deep powder, I longed for the nimble Niva I had back in Kazakhstan. The spinning tyres resisted my frantic attempts to dig them out and there was no phone signal to call for help. I was contemplating abandoning the vehicle and trudging the final 10 kilometres uphill in deep snow, when a man from mountain rescue arrived with his family to ski at the pass. Miraculously, he had arranged for a tractor fitted with a snowplough to take them all the way to the top. For an hour I rode on the back of the plough, to find my hero glowing in the setting sun. This wasn't bullshit – it was brilliant.

right: The route taken is shown as a red line on the map, with landmark points along the way (the majority of photographs were taken at places too small to identify at this scale).

RUSSIA

1	MOSCOW
2	KRASNODAR
3	VOLGOGRAD
4	VORONEZH
5	SATAROV
6	KAZAN
7	YEKATERINBURG
8	OMSK
9	NOVOSIBIRSK
10	KRASNOYARSK
11	IRKUTSK
12	KHABAROVSK
13	VLADIVOSTOK

UKRAINE

14	KIEV
15	CHERNOBYL

CRIMEA

16	YALTA

GEORGIA

17	TBILISI

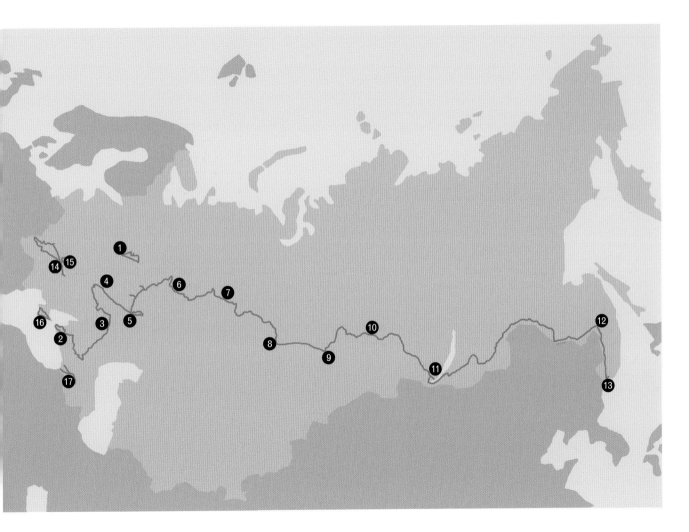

I am forever grateful to Nick Zajicek and Kristoffer Hegnsvad for joining and making the 19,000 kilometres of road tripping possible and fun.

Research and logistic support: Vera Kavalkova-Halvarsson, Kostyantyn Shcherbachenko, Denis Esakov, Ksenia Savchenko, Dmitry Yagovkin, Valery Skurydin, Seance Spiriti, Zhenya Molyar, Nanukå Zaalishvili, Anna Bronovitskaya, Michael Pchelnikov, David Berghof, Raimonda Tamulevičiūtė, Sergey Lutsay, Konstantin Fisunov, Darya Dmitrienko, Ilya Evlampiev, Yulia Kalinina, Sergey Vyskub, Artyom Kravtsov, Alexander Zima, Evgeny Yakovlev, Valeria Agafonova, Victor Lazarenko, Armen Sardarov, Andrei Palamarchuk, John Zmeikin, Dmitry Zhukov.

Published in 2017
Reprinted in 2020, 2024

FUEL Design & Publishing
33 Fournier Street
London E1 6QE

fuel-design.com

Photographs © Christopher Herwig
Essay © Owen Hatherley
Design and edit by Murray & Sorrell FUEL

Distribution by Thames & Hudson / D. A. P.
ISBN: 978-0-9931911-8-3
Printed in China

With over twenty years of experience in more than ninety countries, Christopher Herwig is a Canadian-born photographer and videographer determined to find beauty and inspiration in all aspects of life, A firm belief that the thrill of exploration is still alive in the world has sent him hitch-hiking from Vancouver to Cape Town, across Iceland by foot and raft, and through Europe on a bike. Currently based in Sri Lanka, his previous homes have included Jordan, Liberia and Kazakhstan. His photographs of some of the remotest regions of the world – from the Pamir mountains in Tajikistan to the rainforests of West Africa – have been reproduced in publications including *GEO*, *CNN Traveler*, *Geographical* and *Lonely Planet*. He has worked extensively with non-government organisations and UN agencies in some of the most challenging regions, to put a human face to their statistics and bring project proposals to life.

Soviet Bus Stops and *Soviet Metro Stations* were published by FUEL in 2015 and 2019. The documentary film *Soviet Bus Stops* with a vinyl soundtrack LP were released in 2023.